Gilbert & George

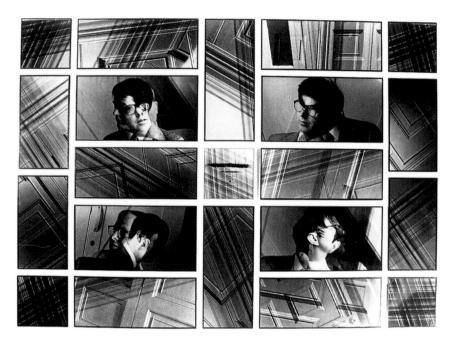

TEXT © BY PHILIP WILSON PUBLISHERS, 2004
7 DEANE HOUSE, 27 GREENWOOD PLACE
LONDON NW5 1LB

DISTRIBUTED THROUGHOUT THE WORLD
(EXCLUDING NORTH AMERICA) BY
I.B. TAURIS & CO LTD
6 SALEM ROAD
LONDON W2 4BU

DISTRIBUTED IN NORTH AMERICA BY
PALGRAVE MACMILLAN, A DIVISION OF ST MARTIN'S PRESS
175 FIFTH AVENUE, NEW YORK, NY 10010

DESIGNED AND PRODUCED BY KEITH POINTING @ POINTING DESIGN CONSULTANCY

ISBN 0 85667 570 9

A COPY OF THE CIP DATA IS AVAILABLE FROM THE
BRITISH LIBRARY UPON REQUEST

PRINTED IN ITALY BY EDITORIALE LLOYD OF TRIESTE

REPROGRAPHICS BY GILCHRIST, LONDON

ACKNOWLEDGMENTS:
MY SISTER, LALLA DUTT, FOR EDITORIAL INSIGHT,
ANDREW LAMBIRTH FOR CONTINUAL FAITH, AND HOME HOUSE,
LONDON, FOR BEING A CONSTANT PORT IN EVERY STORM.

HALF TITLE: DARK SHADOWS NO 6. 1974. 151 X 206 CM.

THE ENDPAPERS FEATURE DETAILS OF 'NAKED EYE.' 1994. TATE MODERN, LONDON.

OVERLEAF: GILBERT & GEORGE IN THE BALLS BAR, BETHNAL GREEN ROAD, 1972.

Gilbert & George

Obsessions & Compulsions

Robin Dutt

PWP

CONTEMPORARY ART

LONDON

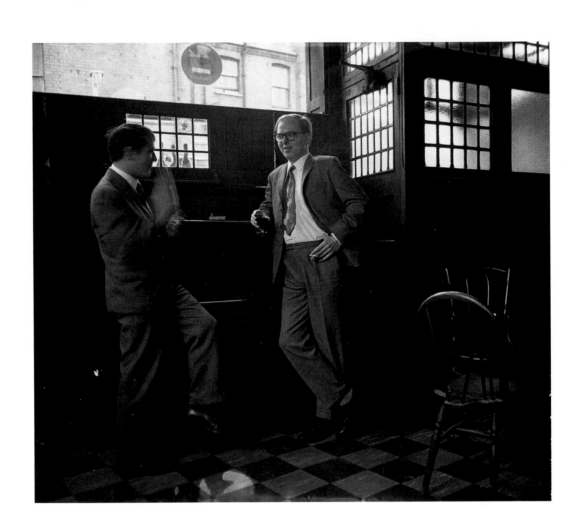

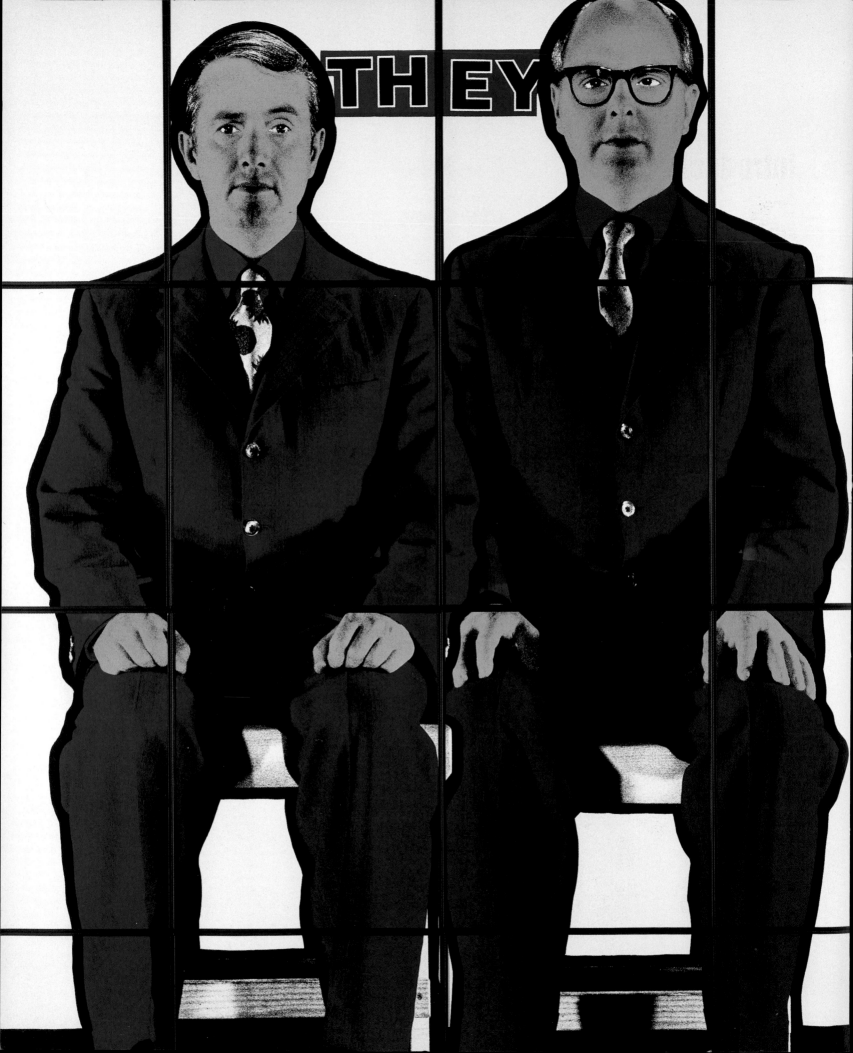

Introduction

Gilbert & George are certainly one of the major institutions of the international art scene. Their presence is felt, experienced and of course, enjoyed by an eclectic audience. These are two artists whose actual lives are an extension of the work they produce. In effect, this makes them 24-hour statements. From their subtly semi-co-ordinating three-buttoned suits to their highly polished, seamlessly finished picture constructs – they are cinematic almost in inspiration. Controversy courts them rather than the usual reverse and their fearlessness of censure and equanimity regarding praise keeps their personal climate temperate.

Generally, despite having worked in several media, most people are familiar with Gilbert & George's most constant oeuvre – the photo image wall works. They call these pictures – and are stalwart about this. But the intention of this book is to show how even very early work – the ironic cut-out words spread on their jackets or the grid pattern pencil drawings – have direct links with the celebrated (and vilified) large-scale works today. The living sculptures – obviously featuring themselves, – translate as central subjects for their particular themes in these pictures. The attitudes are similar, the medium changed.

detail of
They, 1986.

Living Sculpture with Heads, Folker Skulima Gallery, Berlin, 1970.

They, 1986, 241 x 201 cm

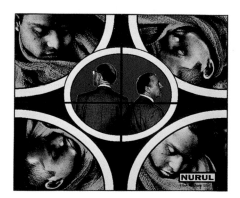

Nurul, 2001, 127 x 151 cm

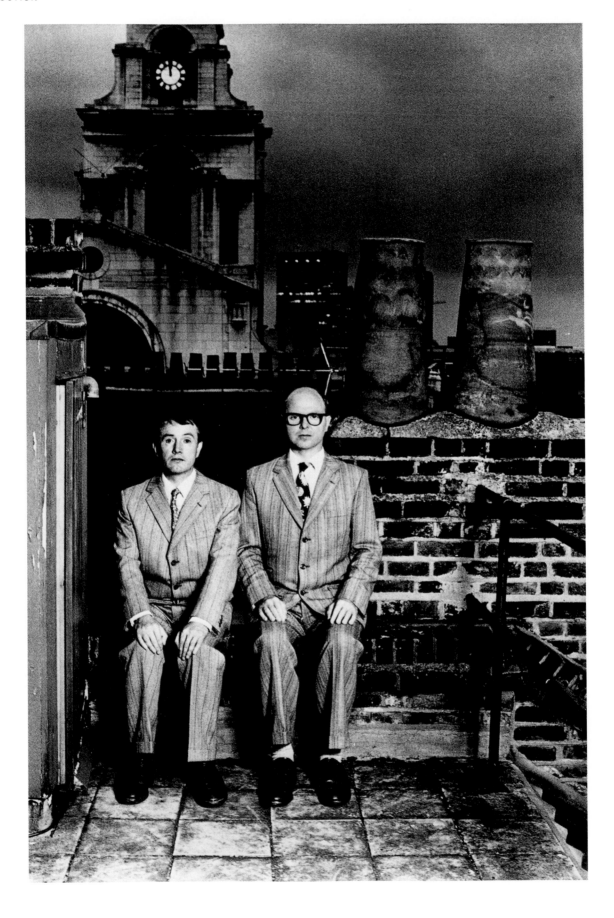

Change within constancy
Constancy within change

WITHIN THE IMMACULATE early eighteenth century façade of Gilbert & George's Spitalfields house, is their laboratory of ideas. And it is or seems to be more a laboratory than a conventional artist's studio. Past the dark vestibule bristling with old catalogues and posters, past a few temptingly velvety rooms dotted with figurines and other objets d'art, you eventually come out into a small rigorously kept square of paved garden. A refreshing leap of soft-green ivy relieves the monotone brickwork.

George leads the way, rather hurriedly, or shall we say with some purpose – grey-suited and serious, all three buttons done up against classical tailoring convention to where Gilbert is standing – grey-suited and serious, all three buttons done up against classical tailoring convention.

All this is an unimaginably long way from Gilbert's impoverished (he calls it peasant) background with all its associated privations and George's memories of a home with no heat, bathroom or hot water. He even recalls children soiling their pants in class because solid school dinners were the first big meals they had ever known.

At a vast central table, strewn with papers, books, steaming mugs of coffee, a small well-used ashtray and a couple of pens, Gilbert & George sit down to discuss this book. On the walls hang huge reproductions of their work, slices of inspirations for other pieces. A gargantuan Cyclops eye leers here, an elongated double portrait insinuates there. A few cardboard storage cases are neatly piled on one set of shelves in the far corner. One 1920's workaday table bears a colourful tome – *Ipek – The Crescent and the Rose*. Otherwise the room is practically empty – except for a large hospital-style plunge sink.

Gilbert & George
on the roof of
their house,
photographed by
Herbie Knot in 1986.

In the adjacent room, the mood is keenly altered by the presence of rather sterile racks and trays, several computers and other esoteric machines. It is now crystal clear that these two rooms – headquarters and nerve centre are recognisably more laboratory than studio. It must, however, be noted that all Gilbert & George images up to this moment have been made without aid of computer technology. There is not one ounce of dust anywhere. There's a place for everything and everything is most certainly in its place. But one realises more and more that this systematic order is absolutely essential for Gilbert & George's deliberate and exacting way of working. And as far as the comparison with laboratories go, think clean, clear, rational, Spartan and utilitarian, not barren brittle, unfriendly, alien and cold.

For more than 35 years Gilbert & George have been an inseparable team, a unit, an idea, a construct – or as they would have it, a 'de-struct'. From the onset, they themselves became a work of art, a sculpture that caught people's imagination first in the incarnation of *The Singing Sculpture*. Their very first art works in this vein involved the use of objects but these were soon jettisoned in favour only of themselves who became subject, object and intent. *Our New Sculpture*, as they first called it, was shown several times in art schools, lecture theatres and the like.

Lasting six minutes, when the routine ended – it was repeated as if providing the perfect second half and perhaps as if to suggest that there is nothing else to say. This piece was presented on and off for about four years and the really big break came in 1969 when they posed on the stairs at the Stedelijk Museum in Amsterdam and caused a sensation.

Gilbert & George are distinct yet a unit. Can one imagine one without the other? No. There are one or two portraits of the two where Gilbert is cradling the head of a seemingly lifeless George. Gilbert's expression is one of total loss. Not twins in any sense, each has enhanced and enabled the other to produce almost a new identity. Could they have produced work on their own? Should they? Do they need to? These are a few of the inevitable questions, which could be raised quite naturally and rationally.

The Singing Sculpture.
The Nigel Greenwood
Gallery. 1970.

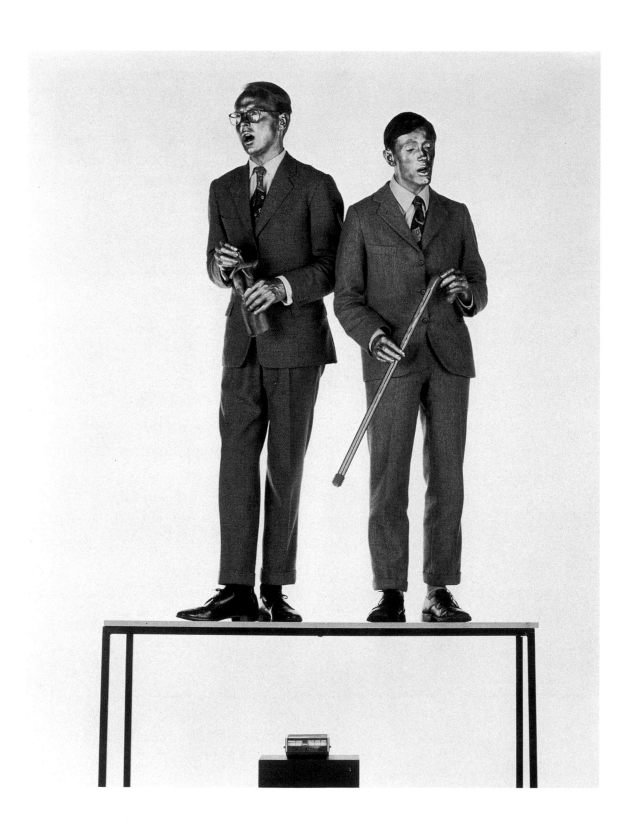

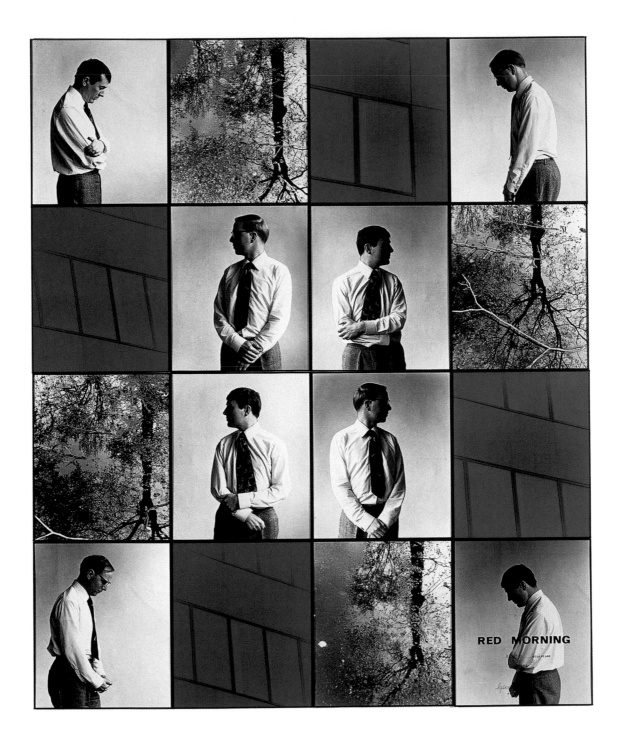

Needless to say, they would not. Forthright in appearance, attitude, mood, speech, opinions and style, their art is created specifically and jointly. Evidence for this is evinced in more of the many portraits for which they have sat. Almost frozen into position, Gilbert being the perfect foil to George – and of course, vice-versa – they appear accessible, yet remote in a marked way. Their seemingly uncomfortable stiffness recalls late Victorian amateur and even studio photography where, because of the primitive nature of the exposure technology, sitters, as a matter of course, had to hold a position for unfeasibly long times. That is why often one notices sturdy tables and solid chairs used as props for weary arms and elbows.

Alternatively, one might be reminded of those iconic and carefully staged images of the Sitwell's swathed in lush pattern and effecting sculptural poses, seductively gloomy.

Much of their work also reflects this precision, constructive rigidity and single-mindedness; there can be no doubt what we are about, the pictures seem to say.

There can also be no doubt about the way that Gilbert & George prefer to be perceived. Theirs is a constancy, which underlines their ethos, their stance, their concepts and most importantly, their confidence. It has not been a particularly easy ride for this dynamic duo – seemingly static as they present themselves. Their work shocks as much as it rocks. But there is certainly one truth. It rarely leaves the viewer without some kind of opinion or feeling. But it is the nature of how they present their art often, rather than the subject, which is a point of high discussion.

Gilbert & George through their career have moved from issues of race, hate, love, sex, nudity, neo-coprophilia, youthquake tremors and so many obsessions besides. But the way, the method of conveying that work is remarkably similar. Only with new and emerging technology have the pictures assumed other identities and quicker and cleaner methods of making.

RED MORNING: Death
1977. 241 x 201 cm

The art is almost always deliberately large scale, impressive, cinematic – The Big Statement – reinforcing their view that what they create are pictures as opposed to photo works or two-dimensional sculptures, which inevitably they are too. It's a neat and tangible contradiction.

Another important part of the art of Gilbert & George is that the deliberate way they make their pictures involves intensive, time-consuming and precise thoughts. They treat shapes, colours, ideas as tools and constructs and the insistency of and depth of the colours they use lodge in the memory. It is difficult to dismiss their style from the mind. Other artists' efforts are regularly forgotten.

One major reason for this is the pair's insistence on consistency. They see no need to radically change their style from inspiration to inspiration. They don't see efficacy of change for change's sake. They develop within the boundaries of their set universe.

All colours, all shapes, all patterns are held 'in place' by a constant grid which of course divides the image into regular sections but which also acts as support and segment frames and also throws the brightly coloured images which often become symbols, almost in relief. Technically it is impossible to produce their vast imagery without division but this technical reality does not seem to overshadow the creativity of the outcome. They have used the grid on their earliest drawing works too. The grid has come to be their trademark. It is *their* trademark. It is *their* formula.

Morning Light on Art for All.
1972, 38 cm x 31 cm.
Edition of 12.

These pictures are windows onto their eclectic worlds.

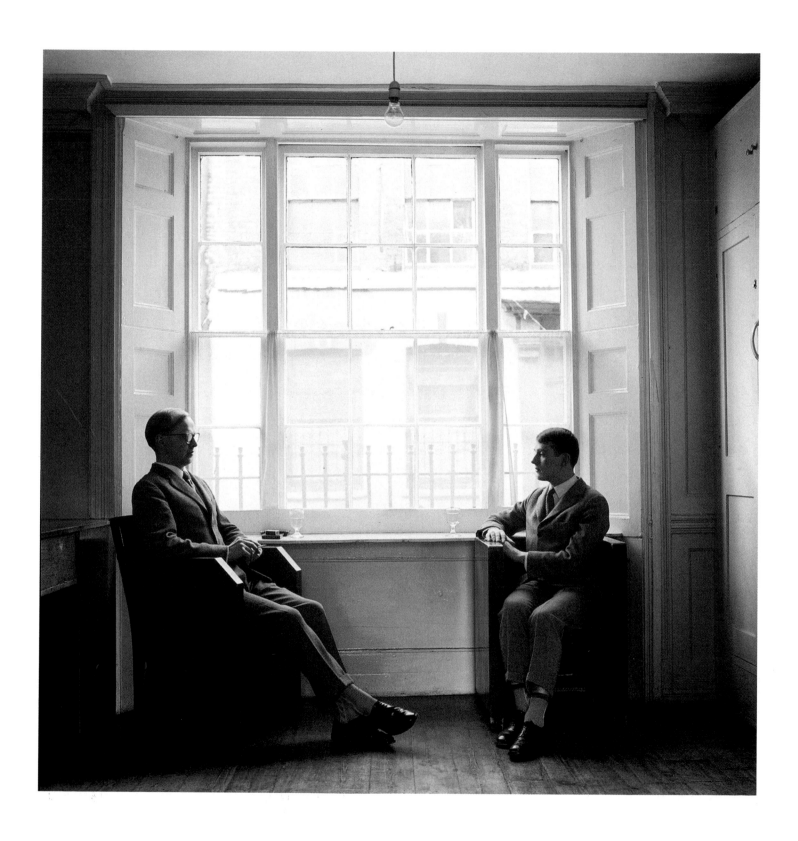

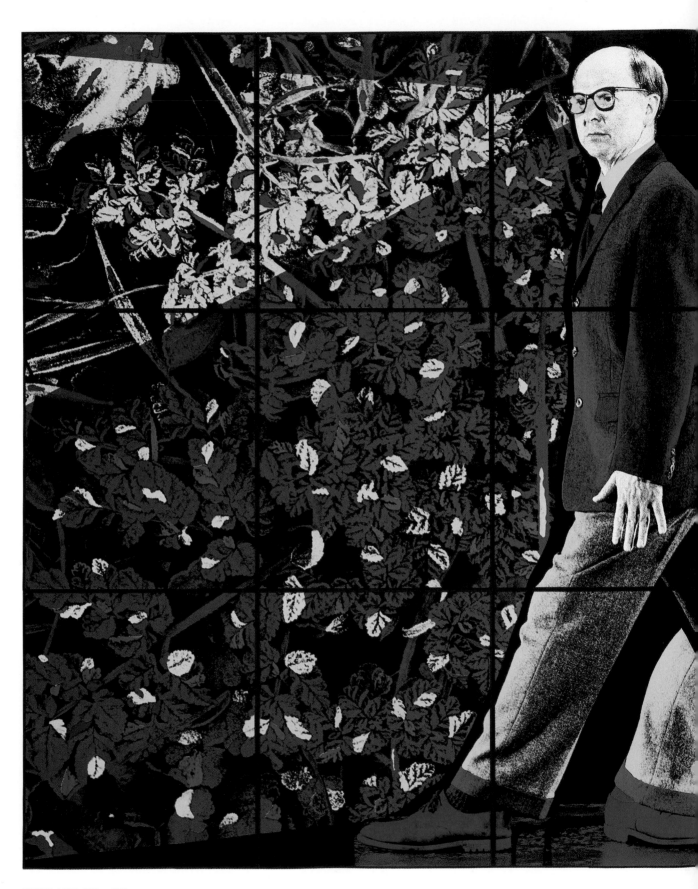

SIGHT. 1991. 253 x 426 cm.

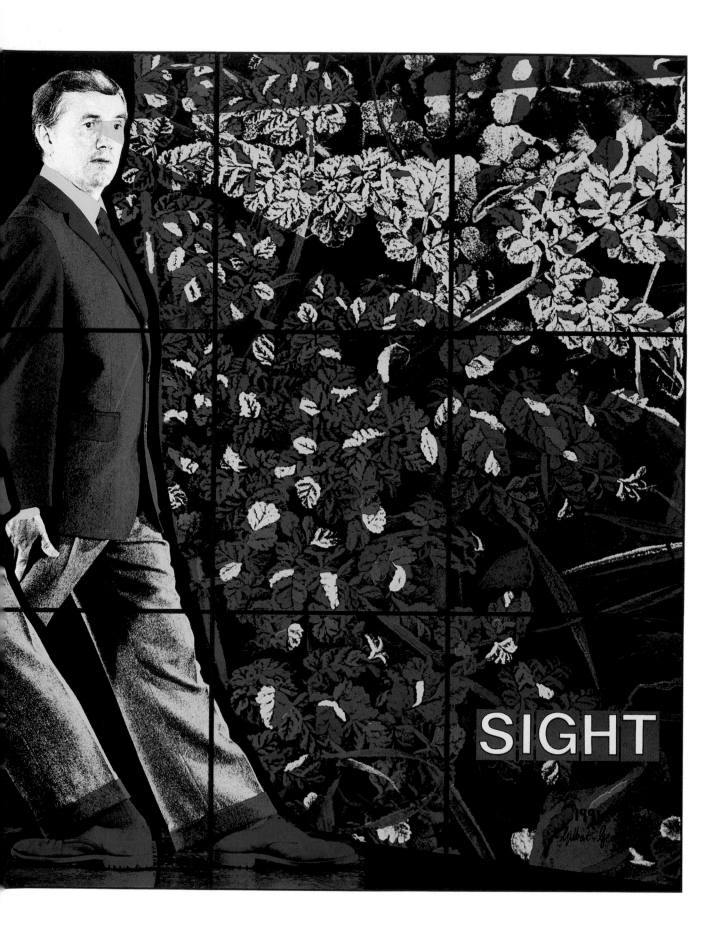

SIGHT

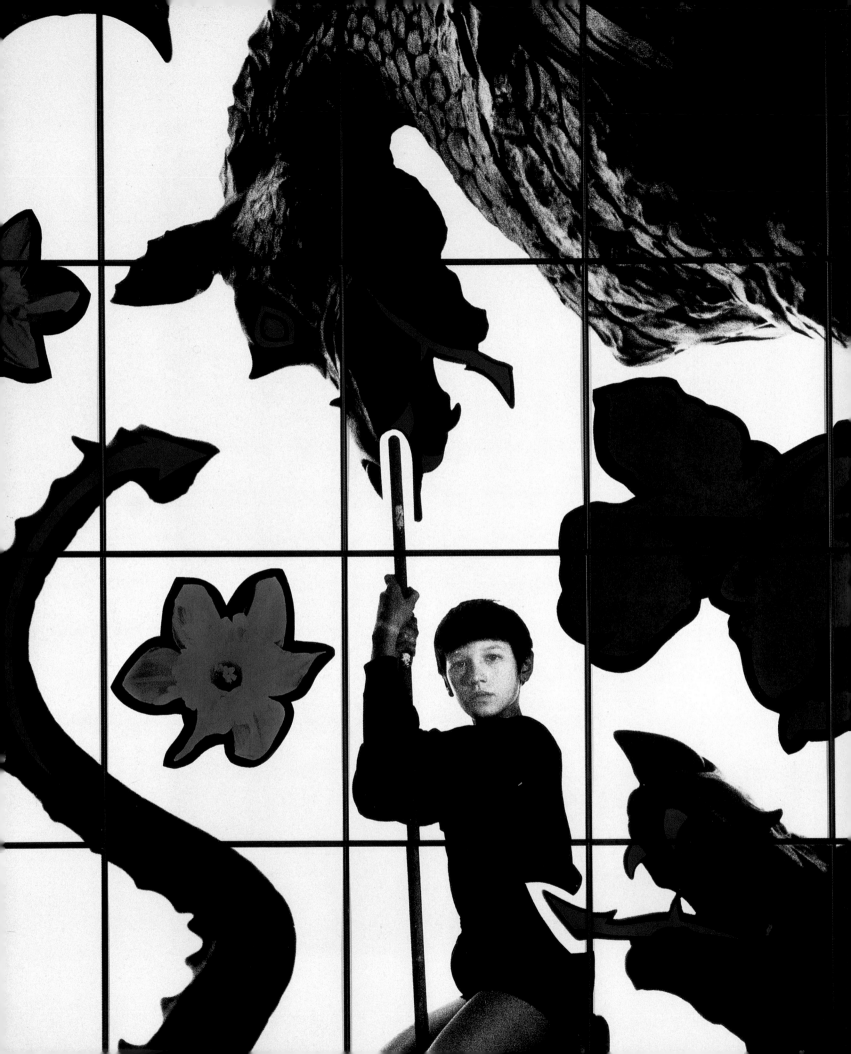

1 CONFORMING

PREDICTABLY, PERHAPS, Gilbert & George are passionate about standing four square against conformity. They regard all conformism as stifling, mean, ultimately dangerous and the reason for so much contemporary dissatisfaction. They cite the fact that as a species we have more of everything than at any other time. In general, of course. We enjoy more freedoms, we are richer, certainly than even our parents' generation and all this despite world conflicts. And yet, we are unhappy and desperate to know quite what to do.

Although presenting their art as both questions and answers, they freely admit that they, too, are also unhappy – famously declaring that they are the unhappiest people in the world. To some this might simply be a pose and reminiscent of dissatisfied and languishing Chekovian spoilt central characters.

Such unhappiness they believe, however, springs from rigid dogma of many types. It also springs from what people are told to believe and what is expected of them. People are defensive, afraid, nervous, angry. And the reason behind all of this is the supposed need to conform so as not to confound anyone else, to merge, to melt, to be indistinguishable and so 'safe'. Gilbert & George believe passionately that changing accepted norms and outmoded values and views may free people to think in a way which liberates entirely. They say –

'It seems that people are going through the most terrifying life. We believe that this is because they have not understood, as we did not understand, that

detail of
Young Saint. 1982.

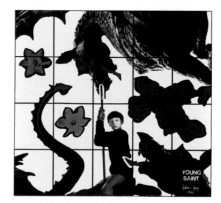

Young Saint. 1982. 241 x 250 cm.

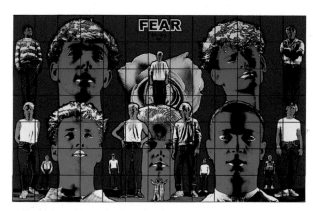

Fear. 1984. 422 x 652 cm. from Death Hope Life Fear.

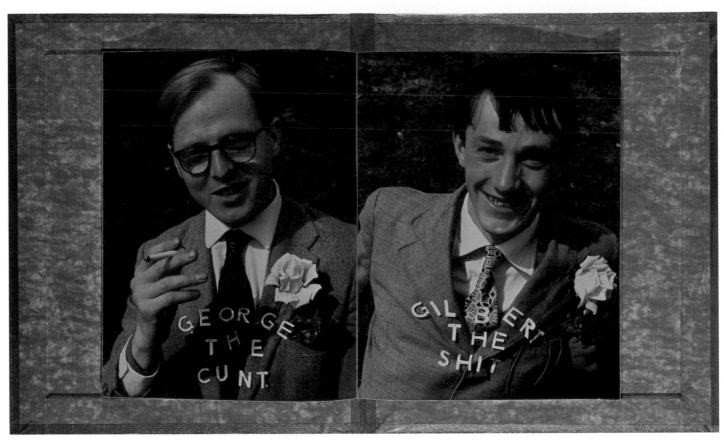

Magazine Sculpture. 1969. Made for and Published by Studio International, in 1970, but in black and white with the 'offending' words censored.

there might be a new way of seeing ourselves. This is going to be one of the biggest discussions of our lifetime.'

At first, religion used to hold the palpable reins of power. Indeed, as far as art was concerned, the Church was one of the two major patrons, the aristocracy being the other. Nowadays, it seems to be popular culture – an equally rapacious master.

Through their work, Gilbert & George have often fought conformism and that is evident from the style of their presentation, using shock tactics to challenge it. But the shock is often accompanied by a mischievous humour. *Design for Foreheads*, worn during 1969 and 1970 (and being precisely that), made several appearances on the social and artistic scenes and featured their initials – without the now familiar linking ampersand – and each other's portraits.

MULLAH. 1980.
241 x 201 cm

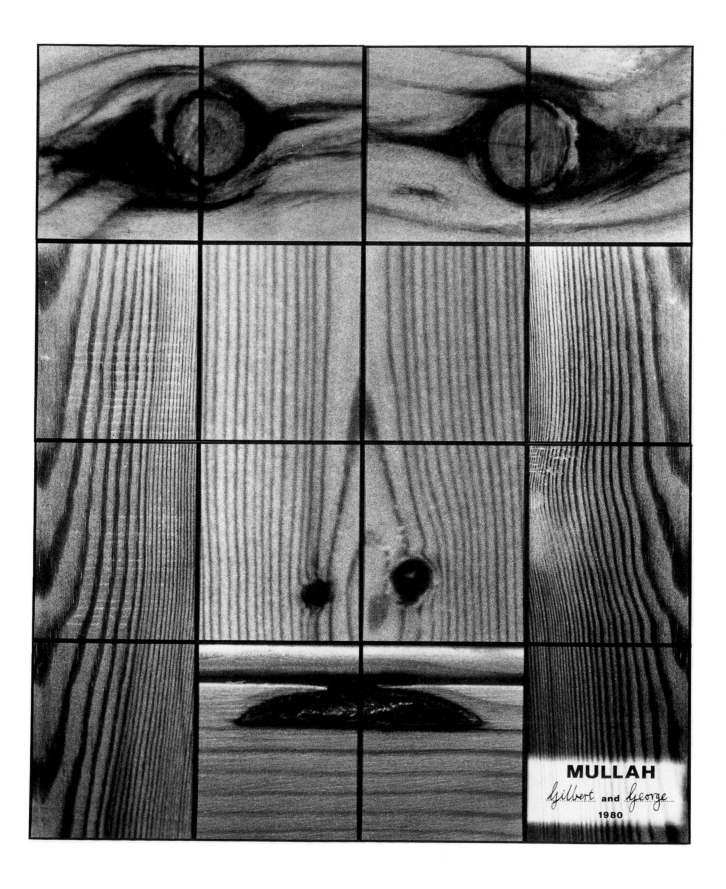

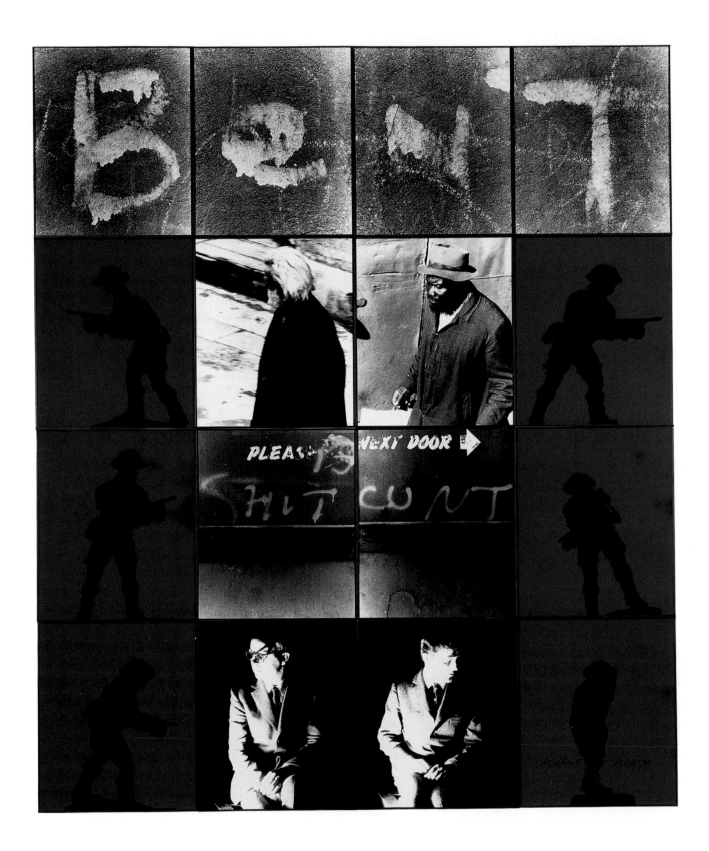

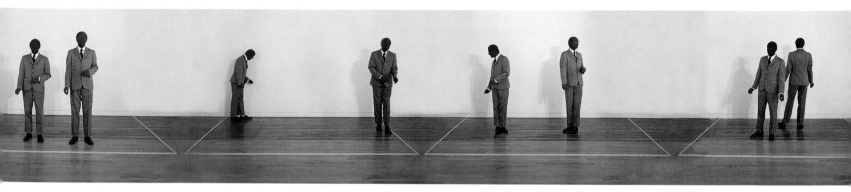

The Red Sculpture. 1976. Sonnabend Gallery, New York.

The unequivocal *Shit and Cunt* Magazine Sculpture was made in 1969 and first published in 1970 in Studio International. But these were early years in universal acceptance of ideas and images and the offending words were censored. Both beam out incongruously at the viewer, roses in their buttonholes, pochettes artistically arranged in top pockets with the cut-out letters decorating their jackets and ties. One must remember that despite the many freedoms brought in by the 1960s, their cheeky piece appeared only a few years after the *Lady Chatterley's Lover* trial, where expletives were uttered as no-nonsense expressions of immediate truth. One might suspect that Gilbert & George might applaud D. H. Lawrence's personal attack on the neo-Victorian stuffiness and conservatism which lingered on in part into the 1920s.

Dark Shadow – a living sculpture book – followed in 1974, complete with hand marbled cover with the slightly disingenuous last line of the introduction – 'We hope that you have a nice time going through it.' – seemingly said in the tone of voice which one might use to express the hope that one had a nice day or enjoyed a nice cup of tea. Naturally this is constructively mischievous.

And humour, mischief, cheek and bravado (whilst wearing the most inscrutable facial masks) have always been a vital part of their way of working. Their static stances and jagged living sculpture moves prove this in innumerable images of them. Their carefully made and insistent pictures – regardless of content – provide working echoes.

BENT SHIT CUNT. 1977. 241 x 201 cm.

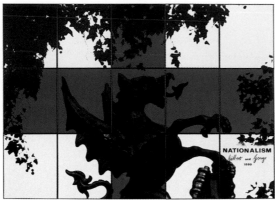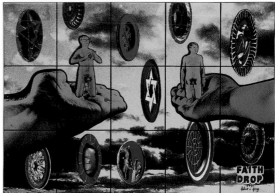

Nationalism. 1980. 181 x 250 cm.

Faith Drop. 1991. 353 x 355 cm.

Surprisingly, perhaps, Gilbert & George have called themselves 'sculptors' which is bound to inflame some. A daily, incidental stroll down Fournier Street (or more pointedly doused in vivid vermilion as the living *Red Sculpture* in Brick Lane in 1996) reflects and reinforces this idea. They *are* their work itself. One might remember Jean Cocteau's edict when he reminded all those who criticised him for indulging in too many disciplines. 'So I have,' he countered before providing the rejoinder that they are all branches of the same tree – and that tree is Poetry. However, it was Gilbert & George themselves who changed this original appellation to 'artists' after 1977 and the *Dirty Words* pictures.

In a similar way, everything that Gilbert & George do or create may be thought of as Sculptural – even the postcard messages. Perhaps this comes as no surprise, considering that even as early as 1967, the sculptors Anthony Caro and Philip King amongst others were tutors at St Martin's College of Art. Gilbert & George were attracted to them but, of course, their admiration did not extend to celebrating their masters ideals and ideas similarly. They intended to create sculpture and be sculptors in a wholly different way.

In 1968, they created their first exhibition together, virtually by chance, for the end-of-year exhibition *Snow Show* where they displayed different objects placed on the floor – somewhat teasingly – as visitors were prevented from entering the room because of a Perspex slice which replaced the door. The whole had, therefore, a sense of clinical preservation, isolation and sterility – a no-go zone where you could look but certainly not touch.

CARRIERS. 1994. 253 x 213 cm.

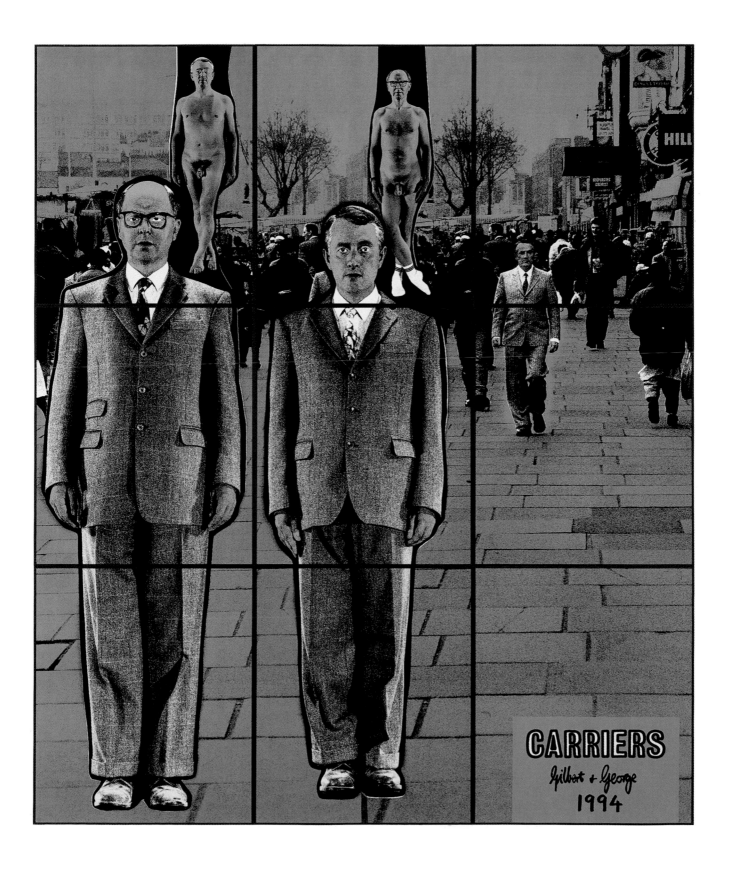

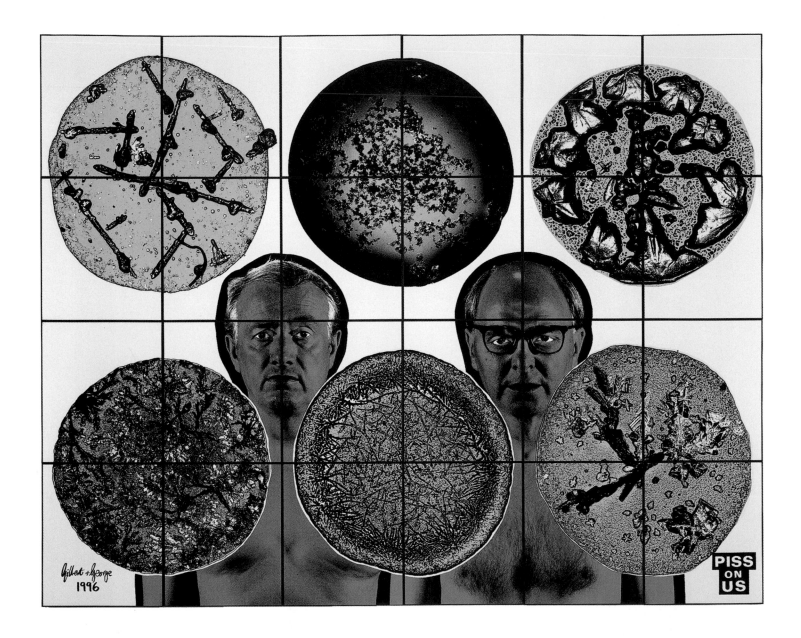

Living life intensely, feeling intensely, being intensely and so, for them, living as honestly as possible, is Gilbert & George's credo. They seem to conceal nothing – unpleasant truths, political incorrectness and so on – no more tangibly displayed than in the 'Naked Shit' pictures. In their 1970 untitled pronouncement, which attempts to decode their purpose, they are unequivocal about the simplicity of their lives. As one reads through it, it seems that from what they say, they are indeed conforming to a certain normality. 'We are only human sculptors,' they state, 'in that we get up every day, walking sometimes, reading rarely, eating often...'

But amongst the everyday banalities they throw in a few unexpected thoughts – 'dying very slowly,' 'Laughing nervously,' 'waiting till the day breaks.' There is certainly a poignancy here which seems to emanate from their very core and might remind some that for all the seeming pose and artificiality of their stance, their hearts are heavy, huge and targets to boot and that they are not only waiting for the day to break but all too aware of when the last day will break – for one or other.

As a couple, they also flout convention and conformity, obviously more startling 40 years ago than now. But still, their symbiotic dependency is hardly commonplace and their relationship has outlasted several more 'normal' ones. One in three (and rapidly descending to two) marriages collapse and homosexual couplings in general are not particularly noted for their constancy or longevity. But they would be quick to state that they even dislike the label 'gay artists' or homosexual in general, viewing them as ways of typifying and boxing in. 'Sex, yes, sexual, yes,' says George in a 1995 interview with Simon Dwyer, later adding in the same interview, 'We don't even understand what a man and woman are.' If they feel constrained by such basic truths, their contempt for convention is rather obvious.

PISS ON US. 1996.
338 x 426 cm.

The very word 'gay' is something that grates. They trace its origins to the London prostitutes of the mid-nineteenth century, the daughters of joy by a more familiar and misguided appellation. A more modern interpretation might be the homosexual lobby to be treated equally as heterosexuals, hence Good As You. Indeed in 1977, they created *Queer* from *The Dirty Words* pictures featuring naturally, themselves, a slice of London skyline and a couple of bowed, anonymous heads. The American gay community was not best pleased when it toured The States in 1984 to 1985.

Fighting conformity by deliberately challenging convention through so-called forbidden words or partially concealed niceties has landed them in hot water. But a flagrant disregard of custom, habit, tradition and ideology – at least that which has martialled men and women (and so has made them unhappy, angry and desperate) – is second nature to Gilbert & George. Fearlessness, it seems, is their by-word for creativity.

WORLD. 1983.
241 x 301 cm.

opposite: **QUEER.** 1977.
300 x 250 cm.

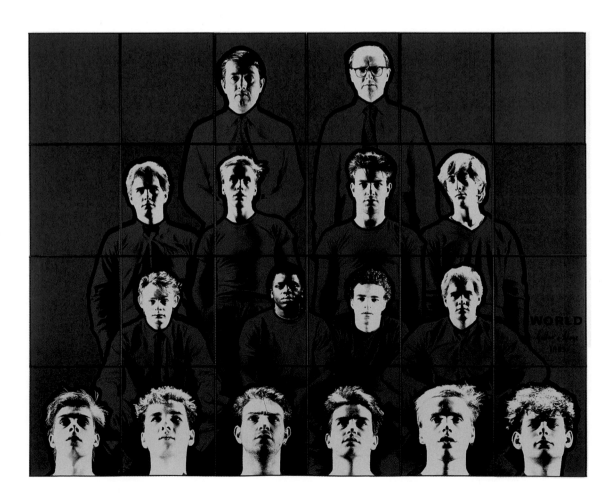

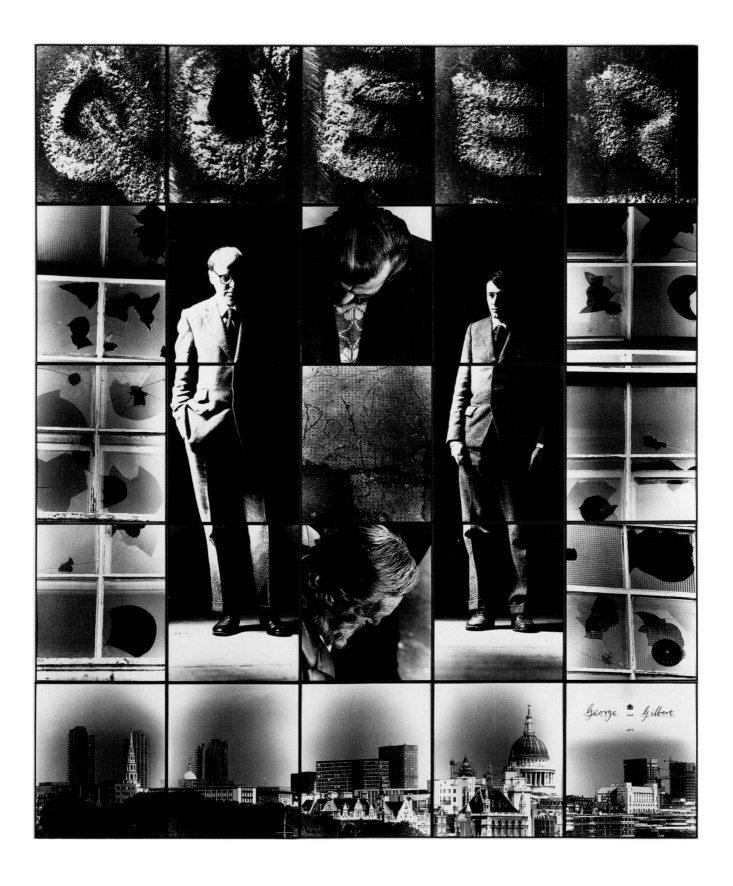

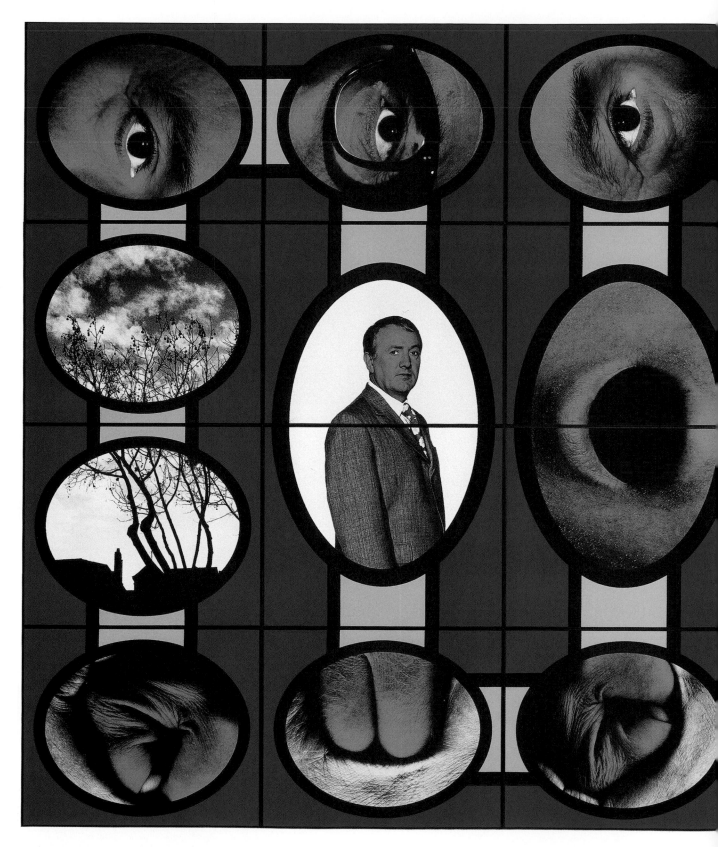

ZIG ZAG LIFE. 2000. 284 x 507 cm.

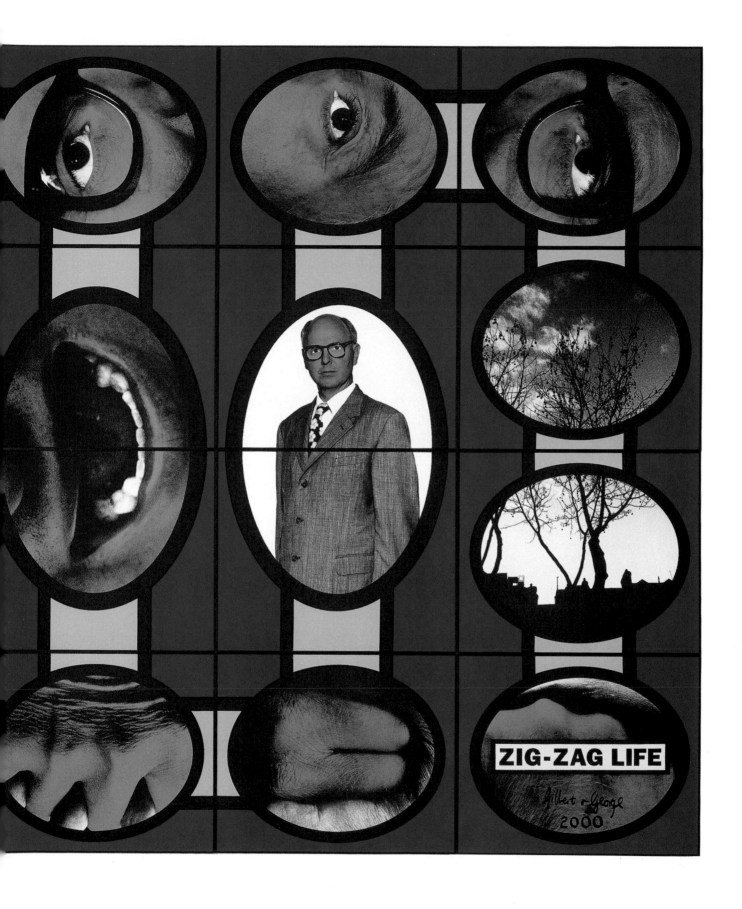

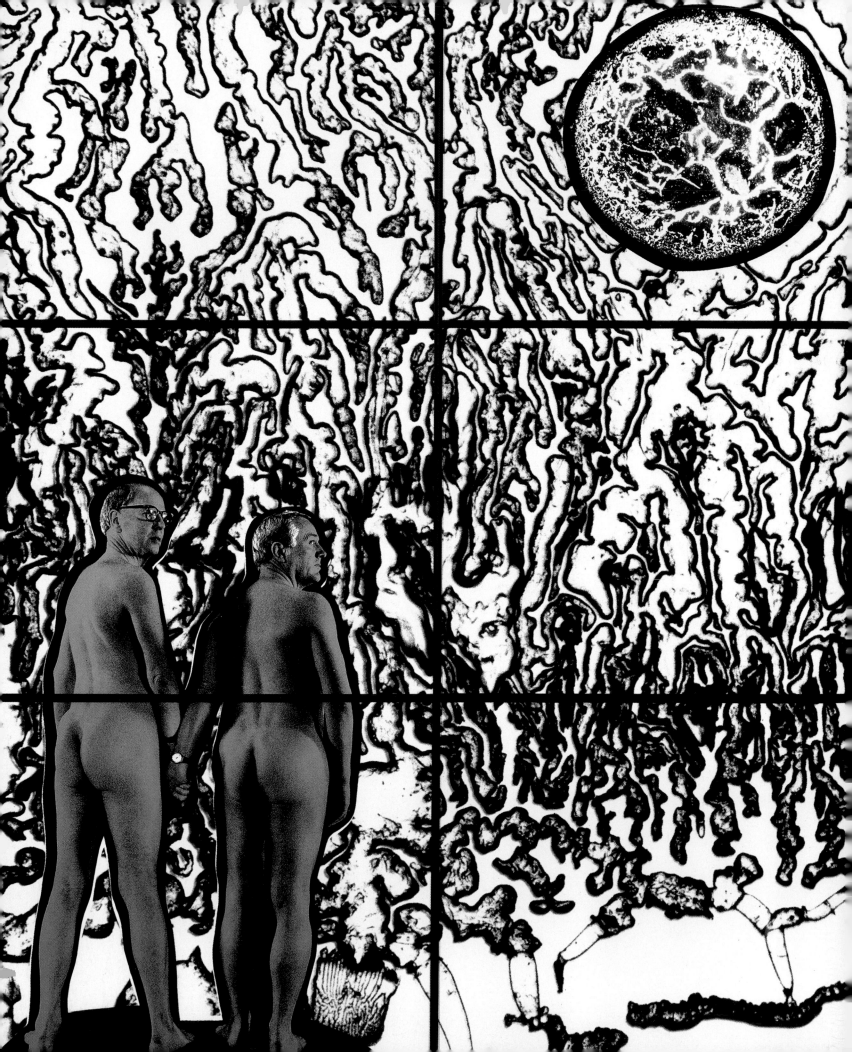

2 FREEDOMS

OSTENSIBLY, ART IS one of the few playgrounds of total freedom; or as Gilbert & George would have it, total freedoms. The plural is important. This is a distinctly fenced-off creative arena where expression – if it is honestly conceived and delivered – has no mental boundaries. Shock is often a natural element of this natural expression and always has been. Through the ages, shock tactics have often been used to highlight other issues. The freedom to do so is central.

Many of today's artists use this sanctioned freedom often in the name of fighting a good cause but frequently that cause is simply to achieve column inches and cash well before any real desire to teach, inform, educate. Gilbert & George treat, by contrast, the gift of freedom very seriously indeed.

Simply being able to be able to shock, to stun, to confound, to stultify, to surprise and disgust is an important freedom thrown into particular relief. This is especially true when one considers that it was an important moment when the pair showed their pictures in Russia and China, two countries, shall we say, where the concept of freedom per se is perhaps understood a mite differently.

Typically perhaps, Gilbert & George are difficult to pin down in themselves, let alone the art they create. They say they are conservatives but create art which is anti-bourgeois. They believe that at heart they are subversives with that vital sense of freedom to realise that through uninhibited expression one might go a long way to shake the world out of its dusty dullness or tactical safety. In order to free themselves politically, so as to have as few labels as possible, they announced that they were low class Tories whilst being the most socialistic, mad, subversive artists that exist in the world. Of course, one could take issue with this view, considering that many artists at some stage, cherish the view that they have discovered something in their work that changes them from artist to messenger of Truth.

detail of
Spunkland. 1997.

Spunkland. 1997. 190 x 302 cm.

Grown Up. 1986. 241 x 151 cm.

MOUTHED. 1992.
169 x 142 cm.

Since the very earliest years of their partnership, Gilbert & George have doggedly perused their concept of 'Art for All' – so that their art speaks directly to people about their lives and not about how they understand art. In *What Our Art Means* they clearly state, 'We say that puzzling, obscure and form obsessed art is decadent and a cruel denial of the life of the People.'

Unsurprisingly perhaps, they despise or certainly denigrate the 'virtues' of socialism, a political, intellectual and social concept that was originally paraded as the cradle of freedom itself. Gilbert & George feel that in essence, of course, it is a fine idea but in practice, a disaster. Who, after all, wants to be exactly as his or her neighbour like those houses on a hillside made of ticky-tacky and all looking just the same? George Orwell's chilling last line in his celebrated *Animal Farm* may spring to mind where, scanning the scene, there was no difference between pig or man. Such are the rewards of enforced political belief.

Art, they feel, is based on capitalism and if it isn't it is often self conscious, pious, stuffy, self-congratulatory and just plain weak. With a socialistic, egalitarian outlook, Gilbert & George argue that you are not allowed to be a free person. In Russia, the state artists were puppets looking to curry favour with those in power and used their considerable technical skills to bolster a new belief for a few crumbs. Under socialism, they argue, you are not allowed to be a free person. And an artist must, first and foremost, be that.

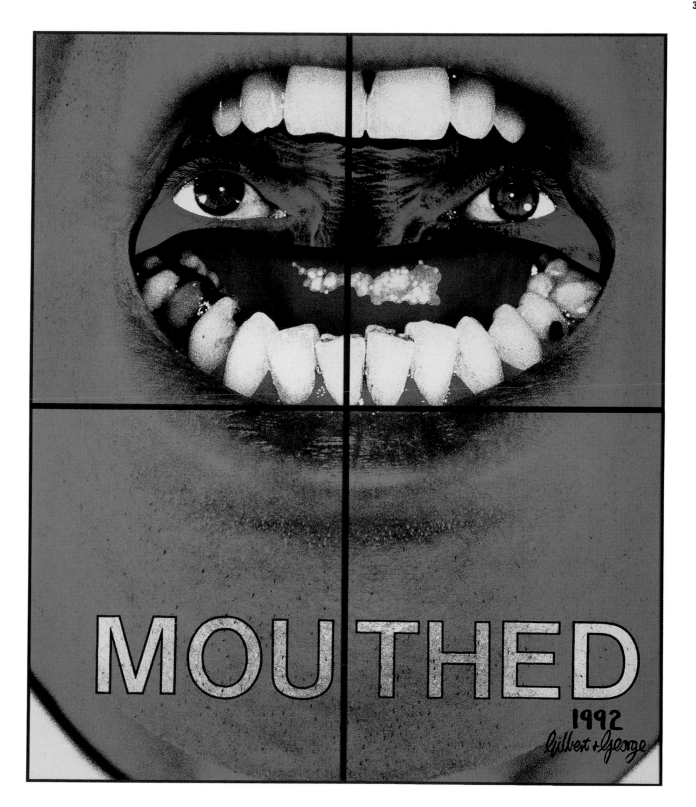

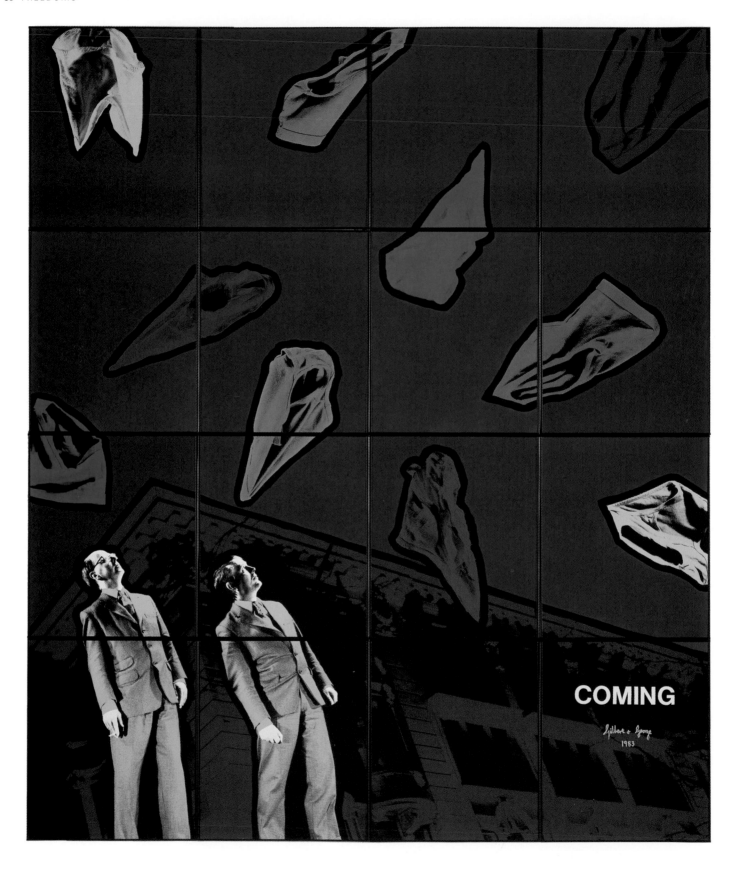

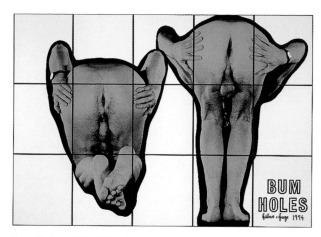

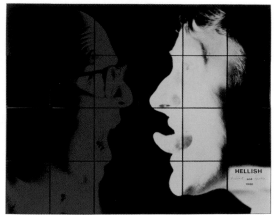

Bum Holes. 1994. 253 x 355 cm. **Hellish.** 1980. 241 x 300 cm.

In their statement *What Our Art Means* first published in 1986 in *Gilbert & George: The Complete Pictures 1971-1985*, each statement of intent, divided into sloganeering paragraphs reads like a manifesto for freedom. 'We want our Art to speak,' they opine. And more directly and alarmingly, 'We want to spill our blood, brains and seed in our life search for new meanings and purpose to give to life.' Arguably, they have done all three.

Freedom to do, to be, to express is evident throughout the pictures of Gilbert & George – especially so when they display themselves in their nakedness – from suit to birthday suit. They make an important distinction between nude and naked. The former is often used to describe something classical, scholarly, tasteful. The latter is raw, hot, sexy, dangerous with a voracious potential. The 'Nude Shit Pictures' doesn't pack quite the same punch as the 'Naked Shit Pictures.'

But it is not simply about surprising or shocking the viewer per se. Tackling unpopular or difficult subjects has never been a problem to them – whether that be sex, death, racial issues, street anger or nakedness. Nakedness and shit are, indeed, two natural partners, since one cannot defecate with any sense of dignity with one's trousers on. They see the combination of both as being logical and natural.

The Naked Shit Pictures to some surely must represent the ultimate freedom to express. What can follow that? Outwardly naked, trousers seductively or innocently half-mast, or removed completely, the artists proudly display in several images the productive contents of their insides as monolithic statements of intent without guile. 'Simplicity for meaning

COMING. 1983. 241 x 201 cm.

means only to be simple,' they have said. 'The best things in life are free, indescribable, painful, delicious, rare and expensive.' (From *Dark Shadow*.)

Being totally honest has never been a problem for them. Unless they lay themselves bare – in every sense – they feel their work has no validity. This also extends sometimes to not being in control – an unplanned and unknowable freedom, the kind of freedom, which is often the result of too much alcohol. In an early interview with Gordon Burn, they discuss the merits and power of this legal drug, concluding that although they don't necessarily like to drink that much and don't even know why they drink at all, getting smashed means you are totally free.

One of course will be reminded of their *Drunken Glasscape*, *Figures*, *Floor*, *Chaps*, *Living* and so on where degradation came so easily in a drink. But there is little joy here – just an alcoholic freedom not to conform to constructs; because drinking largely, usually renders one incapable.

In the minds of Gilbert & George, freedom is not just the obvious ability to do just as one desires. Interestingly and logically, it is also the ability not to have to do anything. They stress the element of choice; one does not have to believe, to work, to declare one's sexuality. 'You do not have to be,' is their edict. Even in the recent past, given the rigidity of society and the whip of convention, one was often obliged to be boxed and labelled.

Today, they say, we have never had it so good. Arguably, it was in the post-war austerity of the 1950s in which the concept of a tangible freedom was born. This was the age of the Rebel, Rock 'n' Roll, and the birth of the 'Teenager' – a word never encountered before. The 1960s broadened this experience into expressions of free love, free sex, a freedom in clothes, music and creative drug use, freedom to abort a foetus, freedom to lampoon and condemn one's elders and 'betters'. Art dealer Robert Fraser, who featured Gilbert & George in the early years described the decade as 'a time of brilliant optimism – of Coke and crisps'. But despite our considerably intensified state of freedom today, Gilbert & George believe there is still a good deal of unhappiness and oppression from religions and

BOTTOMS UP. 1973.
109 x 71 cm.

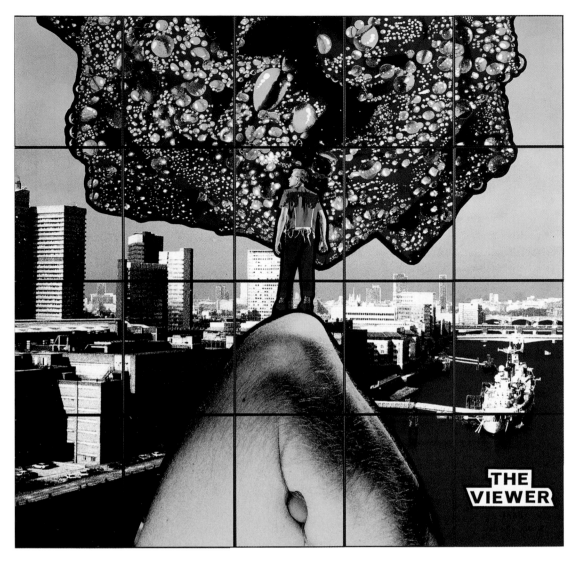

THE VIEWER. 1988. 241 x 250 cm.

political habits of mind. 'People are scared of life, they say, before adding rather charmingly, and we are just as scared as everybody else.'

In *The Ten Commandments for Gilbert & George*, 1995, they plainly state how they regard freedom.

'In our pictures we try to provide some delicate new way of seeing an aspect of life, what a person is or is not. The message transfers itself to the viewer and he or she then has some information ... We want everybody to be free to have their own ideas but at the same time tolerant towards each other.'

Ideas or ideal ideas? The jury is still out.

RAINING GIN. 1973.
197 x 114 cm.

3 SEX

SEX IN THE contemporary world has largely lost its edge: from provocative magazine covers (hardly top shelf merchandise) to blatantly sexual advertising and the use of sexual references in fashion and cosmetics. Sex in a sense has been unsexed. For Gilbert & George, sex is as much an inspiration and idea as any intellectual or actual construct. And although we are familiar with nudity, crudity, blatant marketing of sexual poses and expressions to sell a bottle of perfume, a stick of kohl or a whit of a bra and panty set, the art world is a somewhat different matter.

We have been used to sex and sexual suggestion in art since the beginning of time. Ancient, prancing Priapus figures, erotic Mughal miniatures, and saucy eighteenth-century lasciviousness – we are familiar with it all. But it is perhaps the immediacy and tangibility of the photographic medium in a fine art context which makes Gilbert & George's deliberately sexual works somehow cool and hot at the same time. There seems to be a sense of indifference which of course is part of the conceit. Sex in this context still has a most definite power to provoke, shock, anger and excite – perhaps because it appears so temperately playful and coolly mischievous. Gilbert & George explain in one instance that they want to make 'de-shocks' normal. What normal is, might of course be up for considerable discussion but one assumes that it refers to contemporary society given its current morals and mores – a situation which, of course, changes with time – as it always will.

This is why Gilbert & George are such intensely 'now' artists – a clumsy expression perhaps but true nonetheless. Naturally they challenge convention but they do so calmly. Of course they shock, but they do so in a most gentlemanly fashion. They force one to reconsider mind constructs cast in lead by upbringing, society and education. They highlight the instance of putting an image of a penis on the wall and add that if they can accept together with the viewer pictures of themselves, then we shall all be different.

detail of
Militant, 1986.
363 x 758 cm.
From Class War, Militant,
Gateway. 1986.

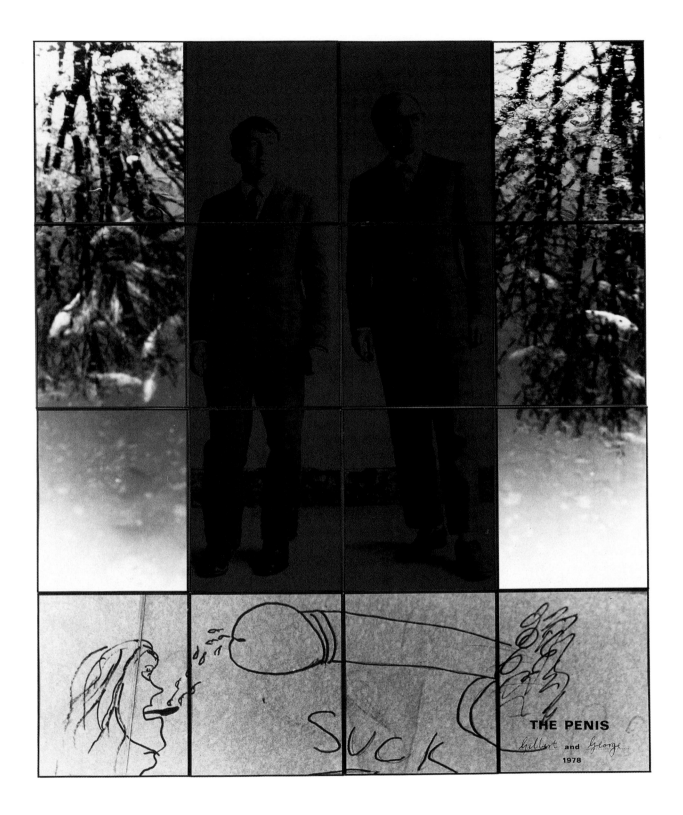

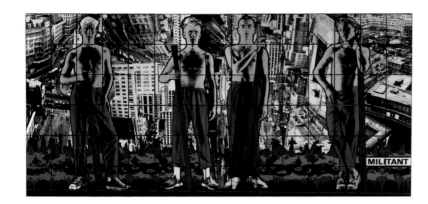

Militant. 1986. 363 x 758 cm.
From Class War, Militant, Gateway.
1986.
2,500 x 2,500 cm.

Or is it the same? But being different perhaps is the best way of cutting ties with a strangulating convention. If shock is removed, could that be the most shocking thing.

Sex in Gilbert & George's art takes many forms. Sometimes it simmers and shimmers just below the pre-Laval surface with images of handsome youths – full to bursting with lashings of testosterone and helped by words which freeze the instant of the moment. *Me*, *Head View*, *See*, *Road* and *Militant*, for example, celebrate a tempered erotic theme, their young subjects sporting crops or quiff tops, rugged jeans, sawn off T-shirts and, of course, the obligatory bare chests and feet here and there. These are sexual images, they are rousing but in an almost clinically pure way. All the messages are received and we are in no doubt about Gilbert & George's intent. But the unique stillness of the pictures has an almost 'frozen' quality which seems to offer a new way of accepting the image. There is almost an innocent sexuality or a sexual innocence about these pictures. No one could describe them as dirty, as such. And certainly not in the contemporary sense. We contrive the erotic story in our minds. The image is the jump-off point.

In other works – most notably those featuring Gilbert & George, naked in several blatant, ironic and hugely humorous positions, sex is to the fore. However, this interpretation is strongly contested by the artists. But is it sex first or the use of their naked bodies as props? The whole concept of the artist being naked in public is as well known as the situation of flinging a paint pot into the face of the same public. Some would argue that Gilbert & George have done both. More observant viewers will notice that in such pictures as *Shitty*, *Naked*, *Human*, *World* or *Carriers*, and so many others what takes over is how the

THE PENIS. 1978.
240 x 200 cm.

So natural

representation appears in total. The nudity is certainly secondary. And even if one is confronted with life-size images of a naked Gilbert & George one cannot help seeing them, comparing, contrasting, thinking – how did they feel doing these images. Was it cold in the studio, did they eat lunch together naked because it was all too much to keep putting their clothes back on, how many erections did they get? Even so, shock is the last thing one feels ….

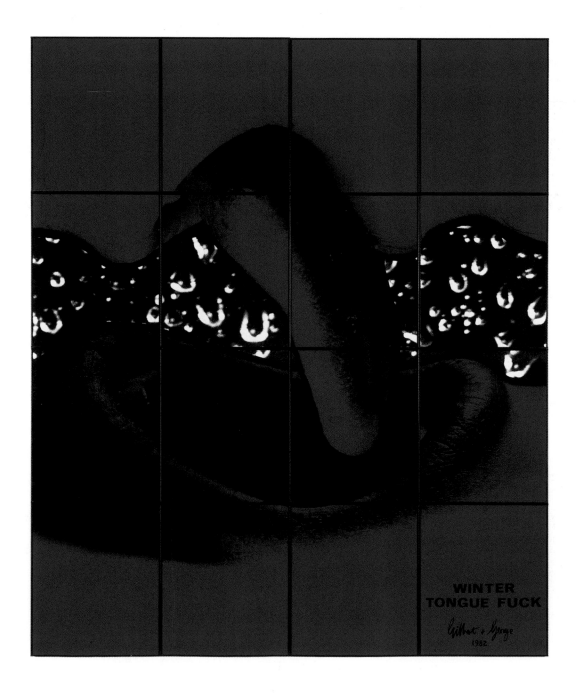

WINTER TONGUE FUCK.
1982, 241 x 201 cm.

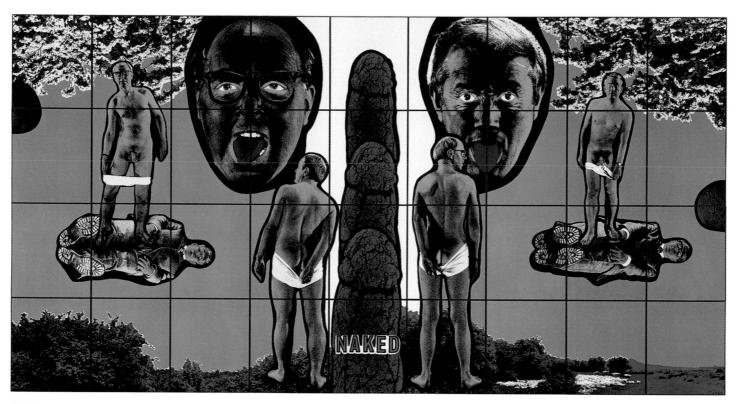

NAKED. 338 x 639 cm. 1994. from Shitty, Naked Human World. 338 x 2556 cm.

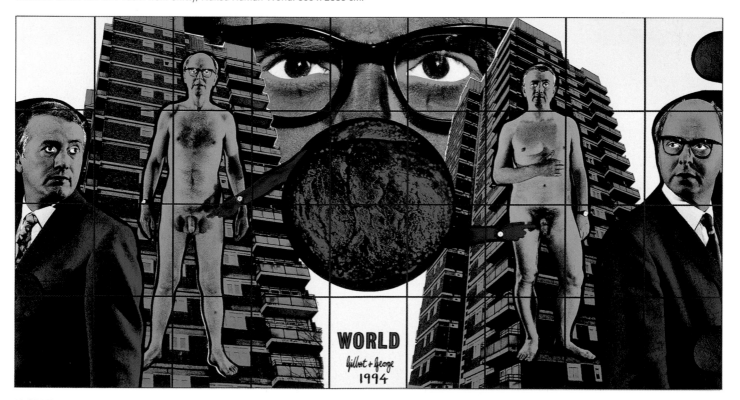

WORLD. 338 x 639 cm. 1994. from Shitty, Naked Human World. 338 x 2556 cm.

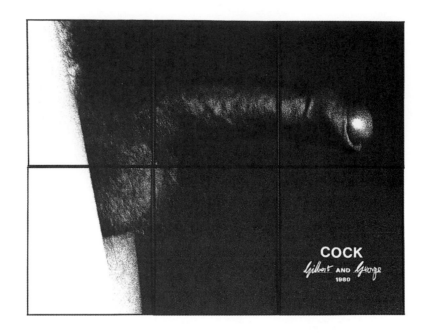

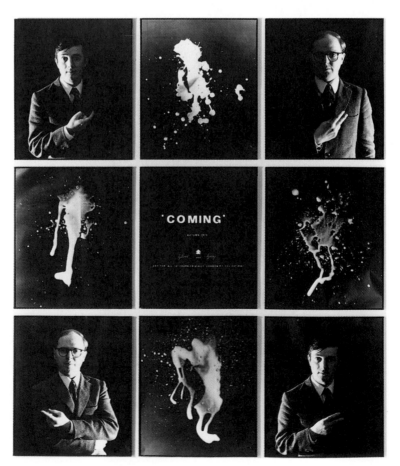

above: **COCK.**
1980. 120 x 151 cm.

below: **COMING.**
1975. 185 x 154 cm.

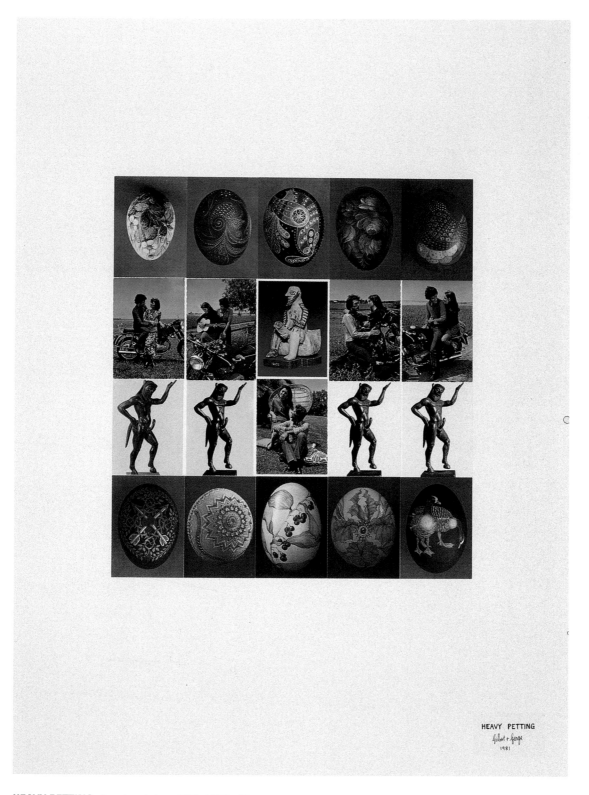

HEAVY PETTING. A postcard piece. 1981. 112.5 x 75 cm.

DOWN ON YOUR KNEES
to your leather clad masterful type. Call if you dare. Tom
0171 385 7775

LET ME BE YOUR FANTAS
Leather, military, cp, dominant type. Tom, 30.
0171 385 7775

4 REINVENTION

GILBERT & GEORGE ARE sure about several things and they are always keen to be informed about things they are unfamiliar with. But one thing is so central to them as to be a fundamental guiding principle. They cite that the day they realised that they were 'living sculptures', their lives changed. They understood that what they had stumbled upon was their biggest discovery – that they had to create Art about Life not Art about Art. Art, they feel, means discovering and reinventing life – not just a new shape or a new form.

Comprehended in this way, it is clear that Gilbert & George, the sculptors, choose and use life itself as the physical as well as mental raw material for their pictures. One can see their point. So much contemporary art is self-conscious in its self-assuredness, decorating its crown with a variety of 'jewels' from PR and marketing to ironic display to celebrity endorsement.

So much contemporary art is too deliberately mischievous, mendacious, twistedly confusing, arch and divisive. All this runs very much counter to Gilbert & George's stance where in one interview they relish the memory of the gallery cleaning lady loving their work when she despised the usual fare.

What is refreshing in so much of Gilbert & George's work is that they use such everyday, ordinary inspirations from wall daubings and the sexy youths who perhaps created them to their own naked bodies and vast blow-ups of sexy personal ads (which

detail of
Tom. 2001.

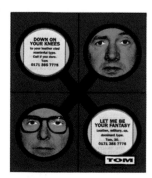

Tom. 2001. 169 x 142 cm.

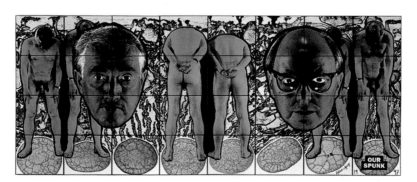

Our Spunk. 1997. 254 x 604 cm.

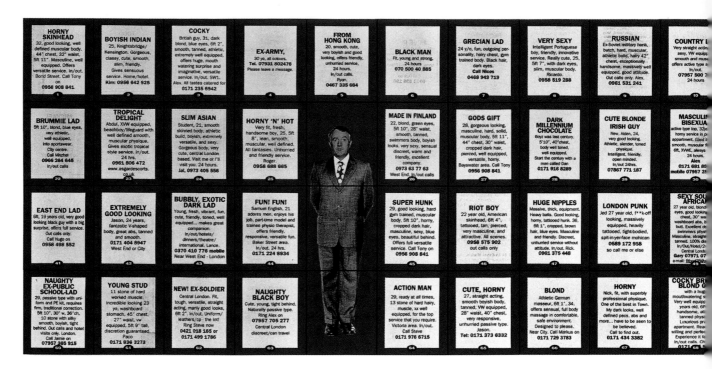

I AM... 2001. 338 x 1491 cm.

ironically, are anything but) in the *New Horny Pictures* of 2001. Here, they make the viewer look at the hot little messages in a new way. One almost feels like a lascivious voyeur scanning the much thumbed back pages of a magazine.

Presenting these works almost as film-screen size pages, Gilbert & George have reinvented the way we look at things. Of course, both appear centre stage in these pictures, formally posed in suits or as full-on target faces and the sex adverts around them become portraits. We cannot see them but surely we can all picture 'Young Lad, 21, 6ft baby face', 'Ryan (23) 5ft 9', stocky, gym trained physique' or 'Carlos, 24 very good looking Latin.'

As with all classifieds and extending to selling consumer durables, the point has to be conveyed quickly and convincingly. There is no difference when 'selling' sex either, it would seem. Each advertiser knows that he is going to be surrounded by competition, so chooses emotive words which can be immediately understood. 'Firm, Active, Smooth, Hot, Horny, Hunky, Clean Cut and Very Well Equipped, leave the potential 'buyer' in no doubt.

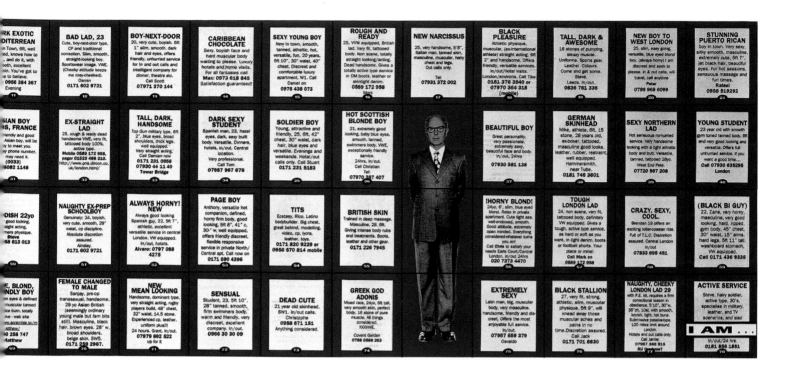

Gilbert & George are famously democratic about giving their art to the people. 'We gave ourselves to the viewer, instead of keeping ourselves as artists separated from the people,' they say, adding also that they managed to become, at the same time, object and artist – a speaking, living object. They also point out that artists create objects which although purport to show life, are lifeless in themselves. Gilbert & George became living artists showing live work.

Forcing, or at least, inviting the viewer to look at things in a new way is challenging and often the works of the artists take bold and strong forms.

In *The Fundamental Pictures*, 1996, they elevate to unprecedented heights (Manzoni's canned faeces included) the very stuff and actual substance of life itself. With titles such as *Our Piss*, *Shit and Piss*, and *Spunk*, we are surely left in no doubt as to their inspiration, nature and intent. These ostensibly and eventually, 'waste products' are conversely and ironically what we are made of but here have risen to iconic levels.

Analysing the very structure of blood, urine, faeces, sweat, tears, sperm and saliva under a powerful lens has reinvented their very nature. We therefore stare at a semi-perfect circle of a rather alarmingly red and undoubtedly beautiful drop of blood. We might then marvel at the fern-like shapes which occur in urine, the craggy planetary pock-marked surface of a captured splash of sperm or the snow-crystal delicacy of a tear drop, as fragile as old lace.

Sometimes the titles, though simply intended to reinforce the message and meaning of the picture, seem like commands, which are intentionally amusing. Hence – *Spit on Shit, Spit on Piss*, and *Piss on Us*. It's almost a series of invitations.

What Gilbert & George have done is to deliberately translate the solid material world (one reality) into the almost always unseen (other reality), echoing the somewhat mystical concept that within us are so many unseen universes. If one drop of blood can resemble an impossibly far away planet, then everything that goes to make up one individual is almost intangible. It is a huge thought and a romantic one. Or is it a hugely romantic thought? 'All is based on human beings, reinventing a way of living', they say.

Even in the way they have chosen to describe themselves as 'sculptors' (later changing this to artists), their blatant camera-produced imagery as 'pictures' and their postcard works as 'sculptures', they can be seen to be reinventing ideas and ideals. Even working as a pair is relatively unusual if not unprecedented in the art world where egos are more fragile than eggshells. Indeed, they feel that they have developed a way of making pictures which need two people – emotionally, too. They also say that they never argue but even if they did, they wouldn't tell.

The Limericks, 1971, was an eight-part Postal Sculpture where the recipient received one limerick each week for eight weeks. The world of public relations is familiar with this device – sucessive, targetted mailouts being referred to as 'Teasers.'

BLOOD ON PISS. 1996.
142 x 169 cm.

In *The Limericks*, Gilbert & George do not make any attempt to disguise the fact that though tongue in cheek, these playful sentences, sometimes bitter-sweet, sometimes very touching, are lines from their autobiography.

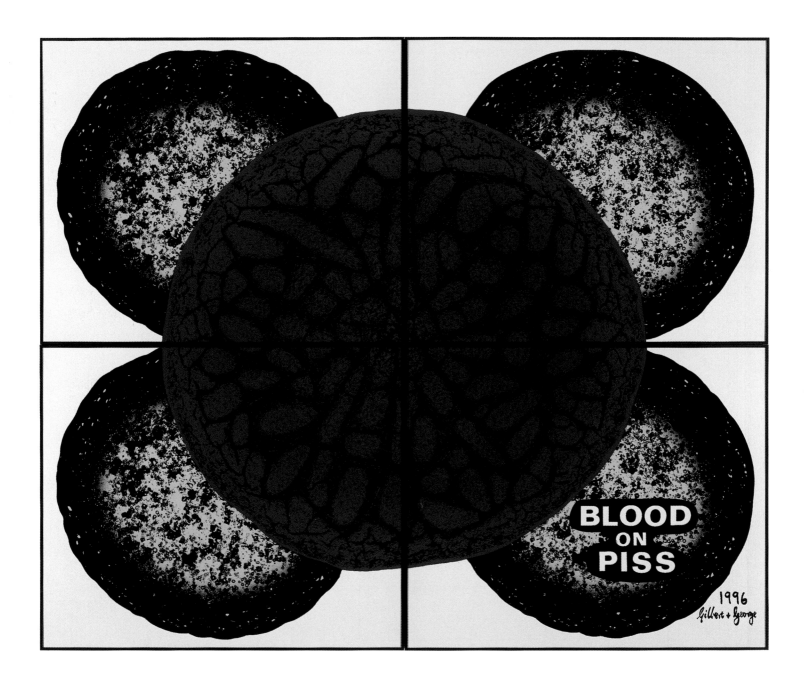

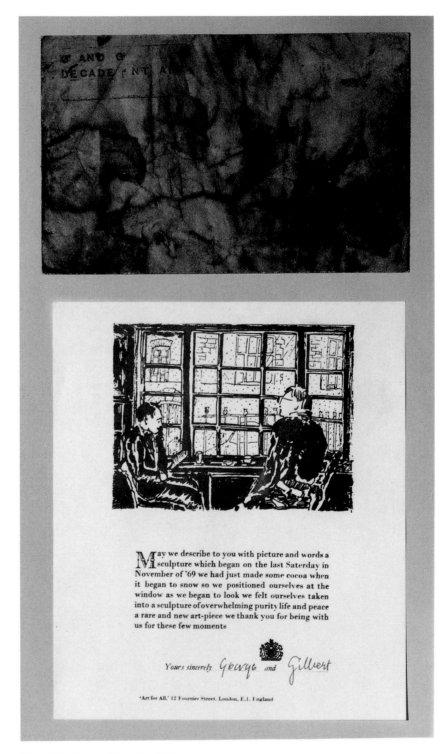

Postal Sculpture. November 1969.

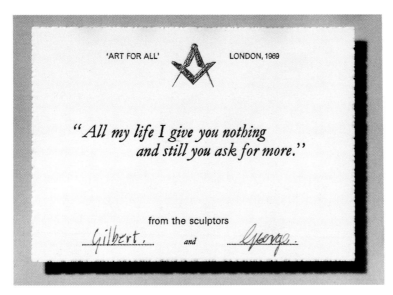

Postal Sculpture. Sent to fellow participants in 18 Paris IV Exhibition 1970.

In a *Postal Sculpture* of November 1969, an image is shown of the two of them sitting at a window watching snow fall. How they describe the moment to the recipient throws the word 'sculpture' into important and unusual relief.

'May we describe to you with picture and words a sculpture which began on the last Saterday (sic) in November of '69 we had just made some cocoa when it began to snow so we positioned ourselves at the window as we began to look we felt ourselves taken into a sculpture of overwhelming purity life and peace a rare and new art-piece we thank you for being with us for these few moments.'

Yours sincerely, Gilbert & George.

Notice the deliberate (or tactically forgotten) omission of most normal punctuation and capital letters – so as to achieve perhaps a fluid, sculptural thought which fixes itself in the mind and remains as indeed, a sculpture on a plinth. The idea has solidified. Even without seeing the image, it is hard to dismiss the scene, the words having chiselled it for us. Its simplicity and disarming, youthful enthusiasm is, in a way, rather charming in its instant naivety.

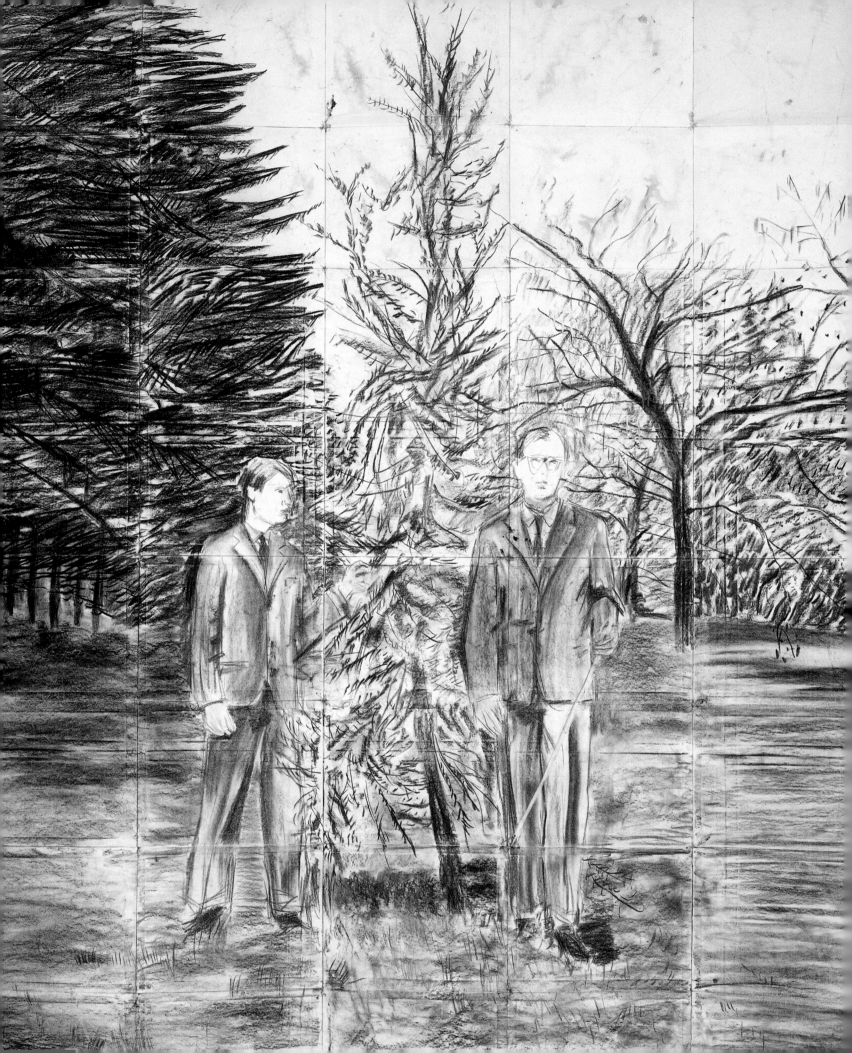

5 SOUL

GILBERT & GEORGE ARE strident in their intent to 'grab the viewer by his or her emotions'. They might appear to make cool, mathematical, precise art which, actually if one studies the physical construction, they do. However, the content of those pictures is anything but. Their images are full of action, statements, demands – buzzing with energy and loaded with impact.

Arguably, they also pour out their souls in the process, featuring their faces, features, bodies – not in a narcissistic way but simply because they have always been the vehicle of their ideas from Living Sculptures to suited or naked characters on their window stages.

Gilbert & George may well regard the soul as the seat of the emotions, an inner sanctum which though hidden under layers of convention is actually the raison d'etre of every person – an inspiration and a force, as valid as a heartbeat. It is hardly surprising that most people are not terribly comfortable with exposing their souls because doing so leaves them intolerably vulnerable, stripped in public with not even a fig leaf for protection. When Gilbert & George decided to do their full frontal naked images, the nudity was not the chief aspect. Surely their souls were on parade too.

All of Gilbert & George's work is created to have an impact and the final intention is for the viewer to remember the picture forever, like an indelible stamp. That is why, though complex in idea and creation, the message each work sends is often, if not always singular, direct, complete and homogeneous. In an interview with Robert Becker in 1982, first published in Andy Warhol's *Interview*, they elaborate on the efficacy of the soul.

'We always say that we produce our work with our thoughts and with our souls and with our cocks.'

detail of
Walking Is The Eternity Of Our Living Moment, It Can Never Tell Us Of An End.
1971. 280 x 315 cm.
From The General Jungle.

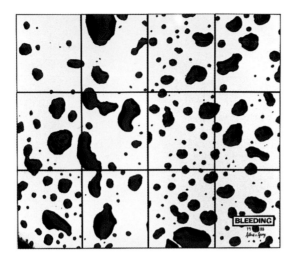

Bleeding. 1988. 226 x 254 cm.

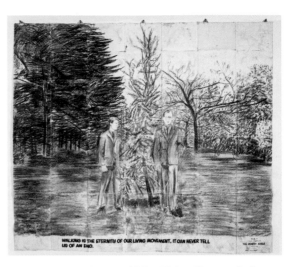

Walking Is The Eternity Of Our Living Moment, It Can Never Tell Us Of An End. 1971. 280 x 315 cm. From The General Jungle.

SUNSET WORLD.
A postcard piece. 1989.
241 x 182 cm.

These three elements, they assert, are the lodestones of their creativity – their Three Graces, perhaps, with precise purpose and not a little humour. And although they want to 'grab the soul' of the viewer, as they plainly state, and to ensure that that picture is never forgotten, they are also adamant that they do not exactly create pictures *for* people. They are resolutely against pictures to 'put up' – pictures that are wanted and liked.

Wanting and liking, they feel, are better applied to curtains and carpets. In the same way as the poet W. B. Yeats regarded the soul as the engine of the body which gives the frail body a real purpose, Gilbert & George's pictures are full of soul that are not easy viewing. If they could speak, they wouldn't be easy listening, either.

What Gilbert & George are excited about and committed to is the message of their work and they cite Francis Bacon whom they state rather categorically, they are nearest to, adding that he didn't know how to paint, only how to make a powerful image. They also say that his message is a simple one of humanity, fear, unhappiness – three concepts which again they can relate to and always have.

When speaking of the soul in the context of Gilbert & George's pictures, it might be as well to dismiss the spiritual or immaterial concepts and, instead, consider the secondary and even tertiary meanings – stripped of any divine or spiritual connection. The soul can be one's moral or emotional nature or sense of identity.

SUNSET WORLD

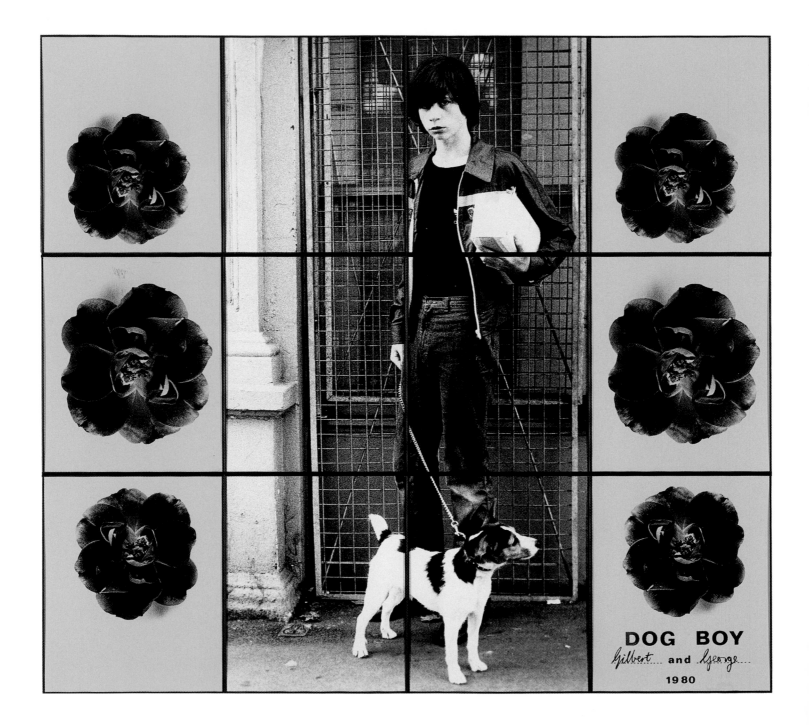

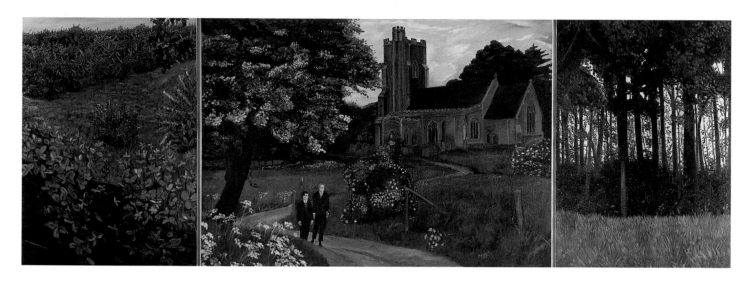

Triptych number 6. From The Paintings (with Us in the Nature), 1971.
1 x (230 x 340 cm.), 2 x (230 x 170 cm.)

It can be a source of intellectual energy or intensity. These meanings hit home more directly and with more purpose. And conversely, something *soulless* lacks character and individuality. It is tedious and uninspiring and lacks or suggests a lack of human feelings.

Gilbert & George's pictures are all intensely about human feelings. What else is there, seems to be the constant undercurrent? With their belief that True Art comes from three main life-forces, 'The Head, The Soul and The Sex', their works are sparkling in their diamond directness, meaning and disarming honesty.

One can so clearly read slices of their autobiography in almost every groups of pictures — importantly and immediately tangible in their early paintings where they appear in a central panel of lush green or wood brown flanked by supporting sections of intensely worked foliage and flowers. These date from 1971 and then developed into photo works reminiscent of the paintings but certainly setting the template — albeit embryonically, for the polished and confident pictures we are so familiar with.

Certainly, one element of Gilbert & George's art in which soul seems most self-evident is in their written 'manifestos', 'letters' or speech-like passages and

DOG BOY. 1980.
181 x 201 cm.

pronouncements. The united, often idealistically romantic, even painful voice is elegantly poetic, calling up instant visions, relentlessly and almost breathlessly.

'We would like to tell of our great pleasure in seeing the early flowers and blossoms, they seem to have a young, fresh youth, so fine and so coloured. We remark the trees with their tight bursting buds... And then may be we will see ourselves in a garden soft and sitting, watching the sun as it gently lowers itself down behind the horizon.'

From *A Day in the Life of Gilbert & George the Sculptors* 1971

Gilbert & George appear to be conveying here the very soul and essence of nature as an almost sensual, seductive inspiration. The poetry is obvious, in the rhythm and the keen imagery. A secular version of Gerard Manley Hopkins, perhaps?

The constancy and co-ordination of their identity as one art-making phenomenon, reinforces a certain purity of the soul when it comes to their goal. They want people to feel intensely, to be deliberately confrontational, to (as they put it) 'go up to the edge' – even if that means slicing their souls to ribbons in the process. Indeed, they acknowledge that they do get hurt and always have done. 'That's good', opines Gilbert, openly.

Gilbert & George would like their work to speak directly and very personally to the viewer. Perhaps it may also be a case of realising that just as there are really only five senses (six, if you are to be esoteric) there are only a limited amount of feelings that are shared between us – basic ones, basic instincts. Love, hate, fear, loss – we can all relate to those foundation stones of our all too brief lives.

Gilbert & George cite *Dead Boards* (1976) and *Dusty Corners* (1975) as two groups of pictures which deal with the utter bleakness of life.

'There is some part of the head, the soul and the sex of every person that can identify wherever they live in the world with those feelings. Very delicate, difficult things to talk about.'

LONE. 1988.
241 x 201 cm.

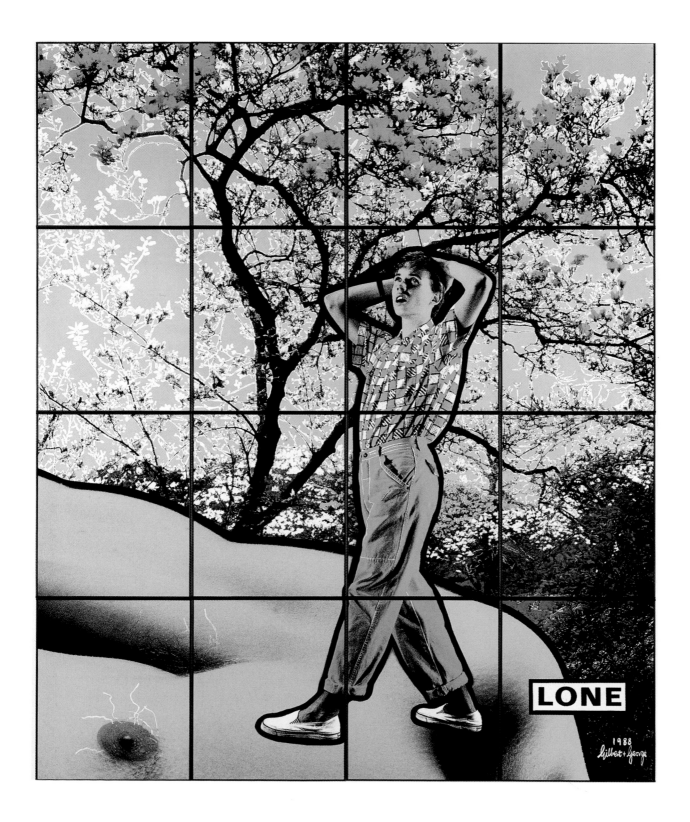

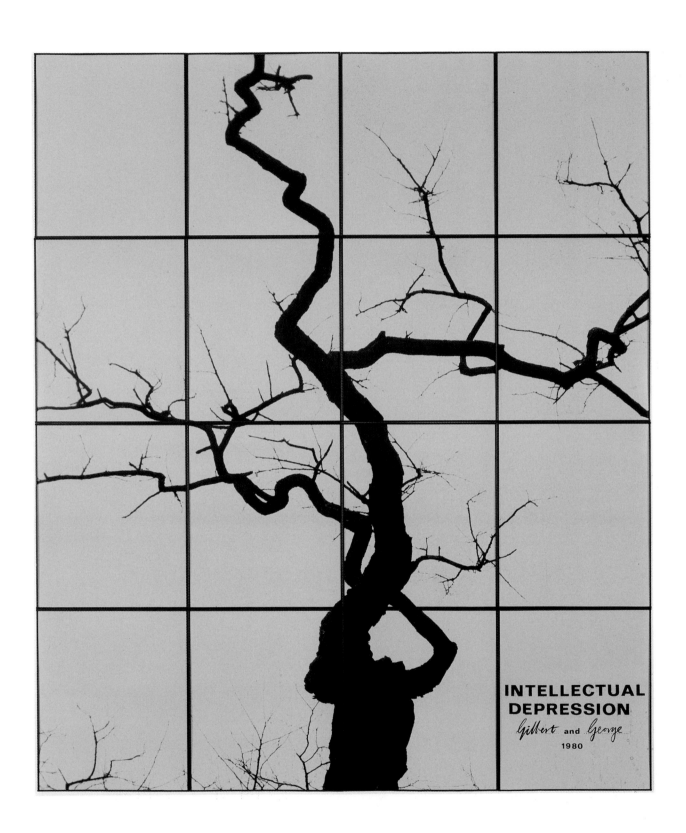

In these pictures, shadowy with gloom and oddly quiet and abandoned, the vulnerability and frailty of the human being in isolation is analysed and the soul is questioned. Gilbert & George immediately identify the soul as a universal receptor of feelings and emotions which shape human life – even Bloody Life.

It may be intangible, in general, a mysterious zone which indeed may not even find very much acceptance by many. Nonetheless, they regard it as a central reality and perhaps an element of this is being able to embrace pain, which makes us more sensitive and aware of more important and lasting things.

Gilbert & George not only realise the importance of pain to an artist but are happy to utilize its effects whenever and wherever possible. Ordinary pain they cite as being very important – those everyday pangs which are akin to those pruning shears of the soul. Memory is the very devil. Lost loves cause our hearts to bleed anew. Lost lives strangle our souls with sorrow.

The fact that artists have to carry life with them is the reason for their pain and they believe that no artist can produce good work without it. Life itself becomes a collection of baggage getting increasingly heavy (and bashed about) with time. They accept, almost cheerfully admit, 'the realism of pain'.

So much of their 'pose' seems artificial, planned, orchestrated and conscious of an audience who might offer bouquets or more frequently, brickbats. Stiffly posing with dainty cups of tea or workaday café mugs at the ready or sticking out their tongues, pointy-Kali style are in turn, formal or an expression of jolly japes and a mischief which recalls their earliest days as the 'terrible twins' of St Martin's School of Art.

But in the final analysis, they do acknowledge the loneliness of being alive and the heaviness of the soul that accompanies this realization. All they want to do is create art that asks questions – and perhaps even answers a few along the way, acknowledging enthusiastically that people are not interested in art itself but instead, are trying to find a way of feeling happier within. In effect, they are looking for themselves; Soul searching by any other term.

INTELLECTUAL DEPRESSION.
1980. 241 x 201 cm.

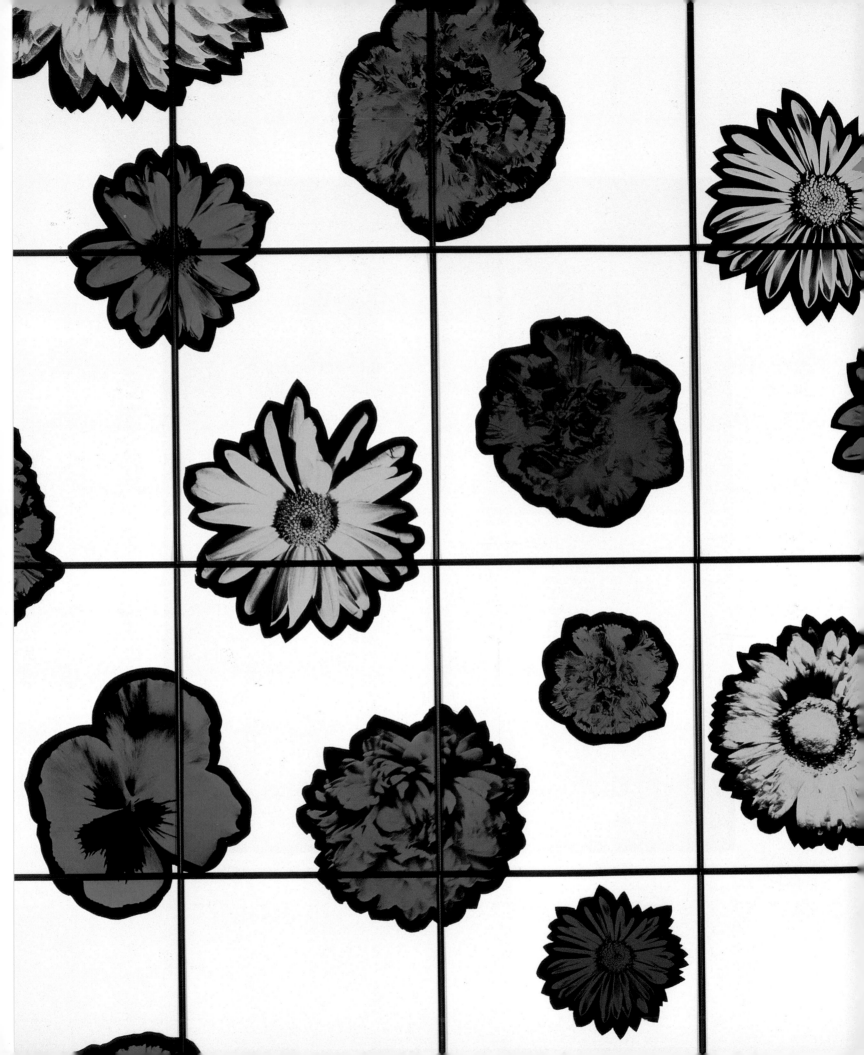

6 LOVE

LOVE, IF ONE were to ask many people, must at some stage involve a goal. Whether that goal is passion or lust or the act of sex is of course dependent on the person. One can love all one's life a person one has lost – and who incidentally doesn't have to be dead – and still retain the wedding ring. One can love an idea, one can love an impossibility. And of course, one can love oneself.

Love in the art of Gilbert & George seems often implied rather than worked out, many of their images seem captured as a penultimate moment before anything actually happens. This does not make them cold works. On the contrary, this 'pregnant pause' before the action serves to intensify thought and fire the imagination.

Much tenderness is evinced in many of these pictures more or less to do with love. Indeed the pair believe that their art puts more love into the world because they understand what the viewer wants to see; a sort of cultural supply and demand. It is a tenderness that is evident, even from the stylised portraits of the pair taken by a selection of talents from the earliest days. There they are, in a loving embrace or locked in a gentle but compelling kiss.

detail of
Coloured Loves. 1982.

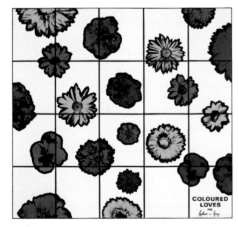

Coloured Loves. 1982. 241 x 250 cm.

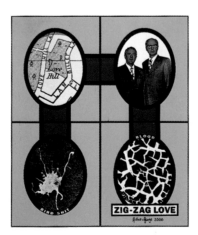

Zig- Zag Love. 2000. 169 x 142 cm.

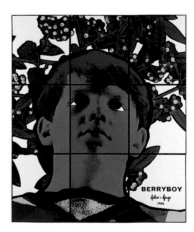

Berry Boy. 1984. 181 x 151 cm.

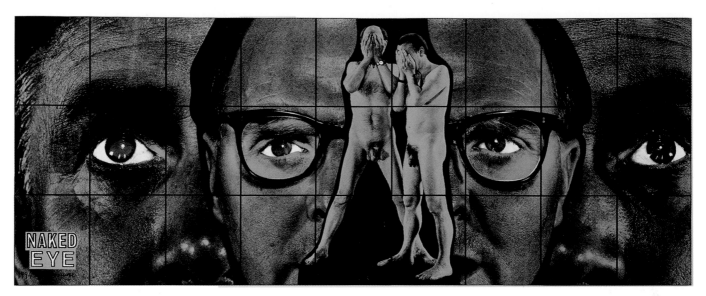

NAKED EYE. 1994. 1253 x 639 cm.

Then there is the portrait where George's steadying and reassuring hand on Gilbert's knee finds its exact reverse counterpart. The merest touch – light and yet deliberate – seems to lack hot passion but it does hint at commitment, peace and comfort – the sort of love which comes to fruition as a slow bloom on a long established tree.

From larking about on the roof of St Martin's School of Art, smoking and giggling to the actual pictures of a naked Gilbert supporting a naked George in an attitude which suggests world weariness but acceptance, love is very clearly a central idea for the pair. And of course, for us.

Protection is very much part of their idea of love. But certainly this love is never sloppy or soppy, weak or wanting, jealous or complacent. Instead perhaps, there is a stoical, mutual dependency, which is naturally not desperate. Their expressions might hold some clues. Straight faced, almost expressionless and staring, for the most part, they almost dehumanise themselves by omitting character traits through their features.

And so the viewer's attention quite naturally turns to the action of the body, the positioning of the limbs and all the silent stories they tell. Indeed, the expressionless faces are the perfect foil to the rest. These pictures are hugely narrative – a complete story at a glance.

LOVE LAKE. 1982. 241 x 201 cm.

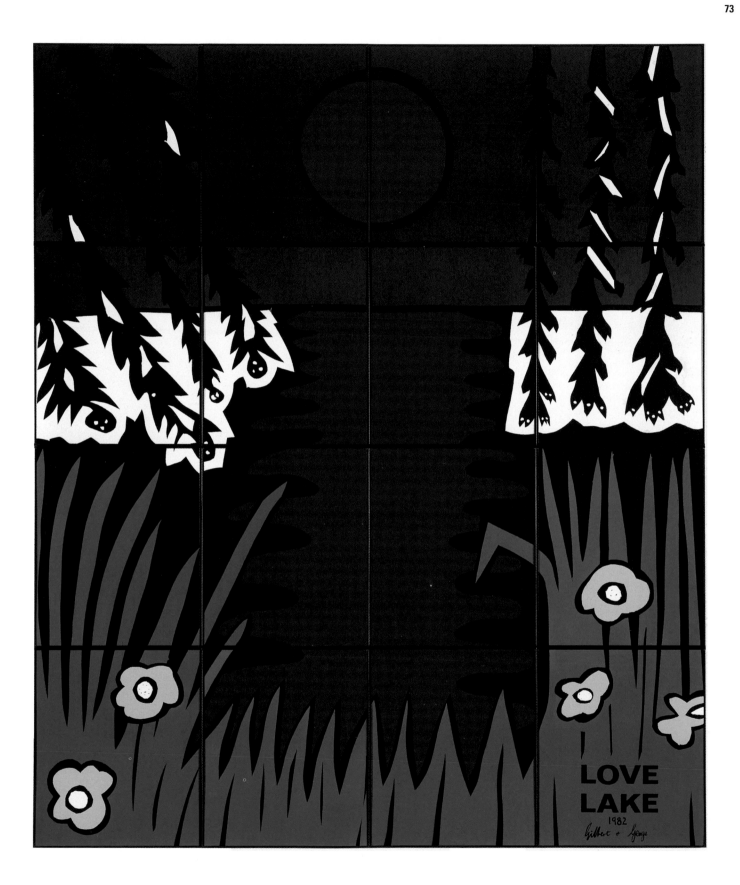

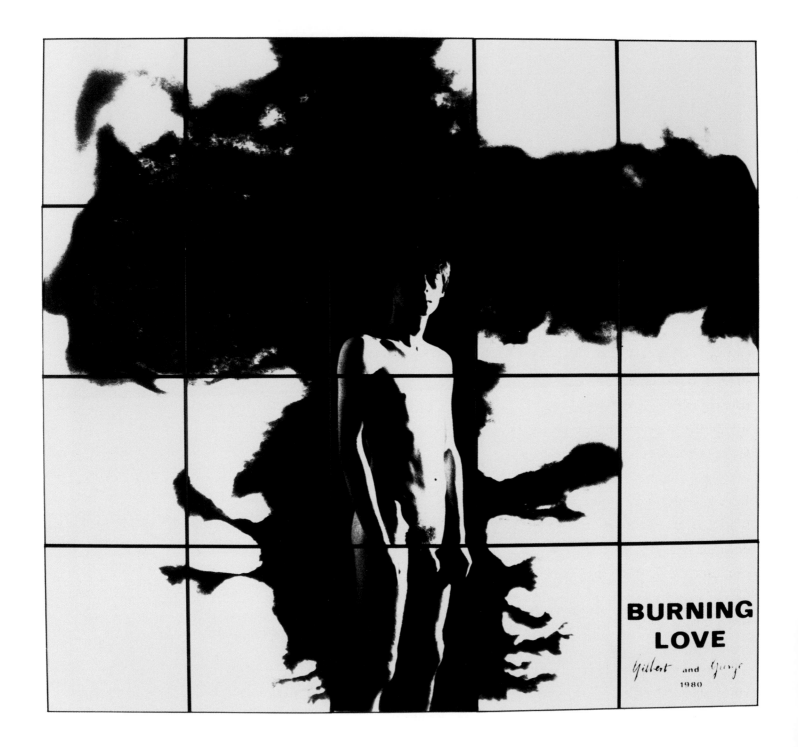

Gilbert & George have admitted on several occasions – in a variety of ways – that they are obsessives. They claim that they want to love the viewer and, they would hope the viewer love them back. The viewer may look at their pictures and see innermost reflections of themselves or perhaps, hopes of what might be. Indeed, their art might stir memories of love.

They recall one lady, after having witnessed The Singing Sculpture with its familiar, sad and lilting *Underneath the Arches*, weeping because the tune reminded her of her dearly departed father. To love unquestionably is one element of the creed of Gilbert & George. They like doing things for people. They identify lost causes in people, set them up, give them support, help, encourage. Surely all of these are aspects of love?

They are huge supporters of young artists like the late and very talented Andrew Heard and his one-time partner, the ironic and street charm savvy David Robilliard who used to share a studio quite close by, near the East End. They loved and featured another young talent, Joshua Compston who ran the gallery Factual Nonsense – arguably the first significant space in the area, before fashion made it a right of way for others. A naked Compston appears in one of their pictures. He now only exists in their work.

Love is depicted in the art of Gilbert & George in typically multifarious ways. Blatant or subtle, it is treated in the same cool and deliberate way. *Burning Love* (1980) for example is blatant enough. A very colt of a youth – and certainly no gelding – stares out of a dark, cloudy mass suggesting a partially occluded cross. His stomach is one you might like to iron a shirt on. His proud attribute competes with the youthful lines of his face for attention.

The tenderness of *Bloody Life,* 1975, is so apparent. Gilbert & George stand vulnerable and isolated – separated by frames with their backs turned to the viewer. The bowed heads, the crumpled suit backs, the whole attitude of the awkwardly placed legs suggests a need to be loved and protected. All around, splashes of neo-neon blood provide the striking and lightning contrast. The downcast faces, the moody lighting reinforce the unspoken request for compassion and the title does the rest.

BURNING LOVE.
1980. 241 x 250 cm.

Both cite a moving moment concerning their 1982 picture *Naked Love*. They recall a boy of 13 or 14, his eyes full of tears, telling them how comfortable he felt standing in front of it. Visual advice, reassurance and endorsement where perhaps none came from parents, friends or teachers. The picture had had its effect.

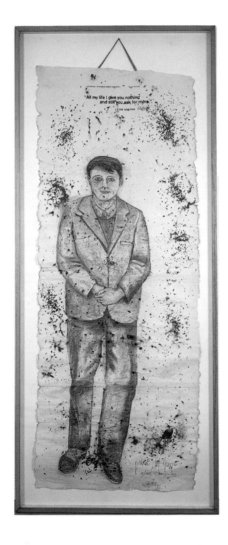 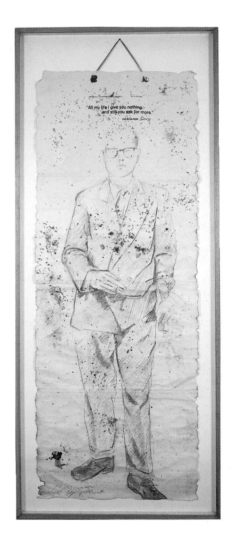

opposite page:
NAKED LOVE. 1982.
302 x 301 cm.

'ALL MY LIFE I GIVE YOU NOTHING AND YOU ASK FOR MORE' 1970.
Each 193 x 75 cm.

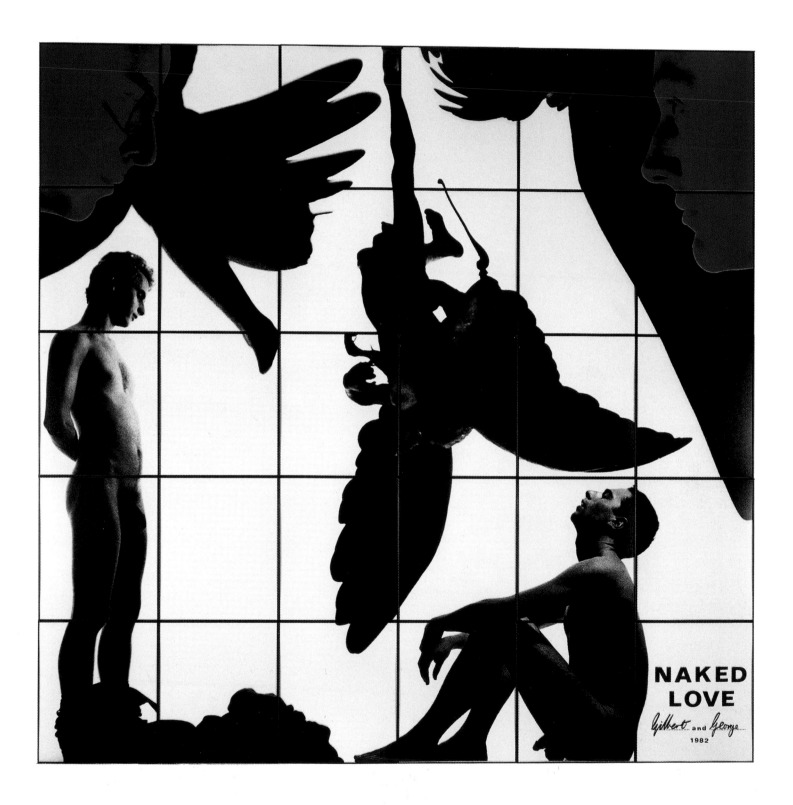

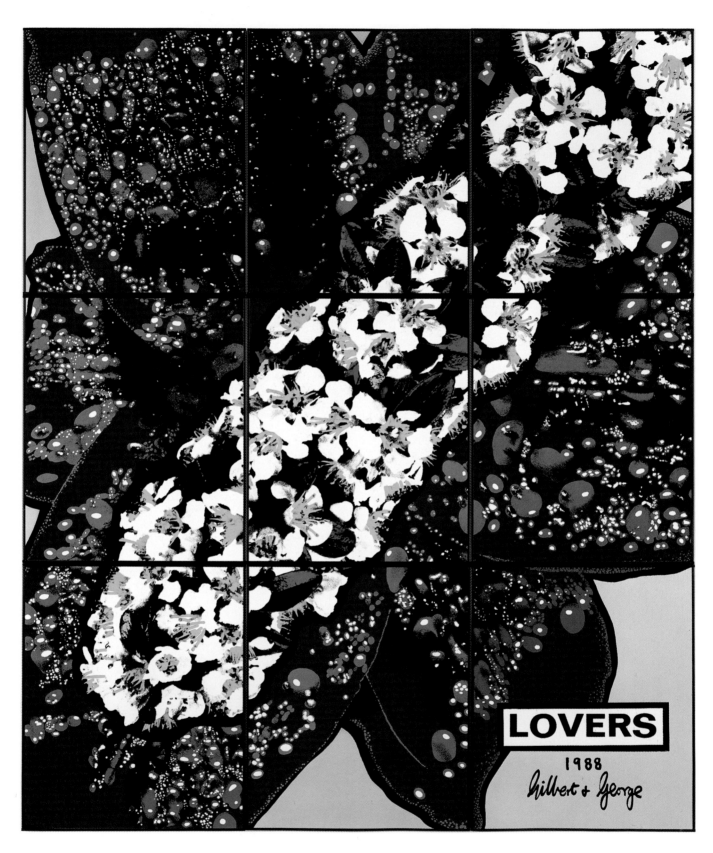

LOVERS. 1988. 181 x 151 cm.

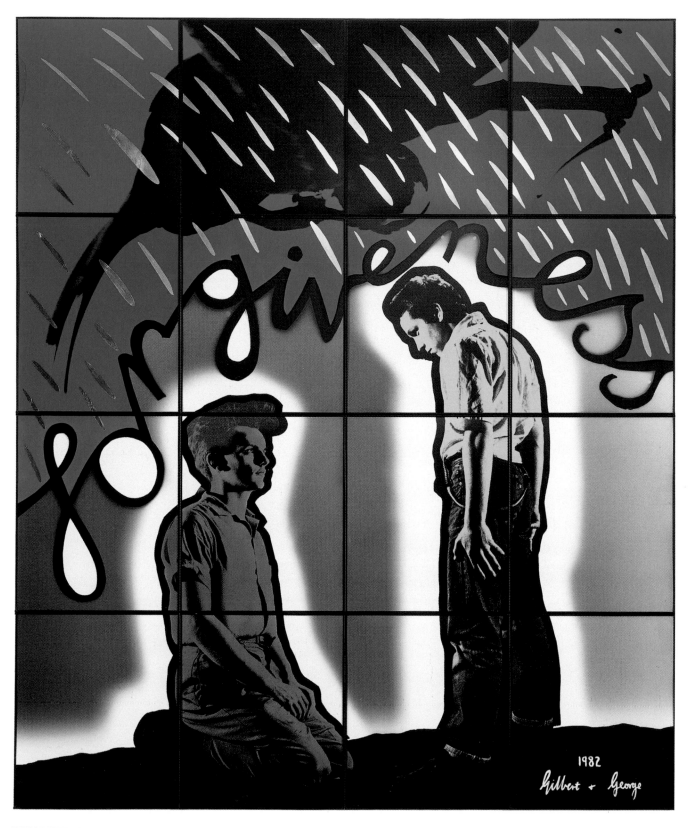

FORGIVENESS. 1982. 241 x 201 cm.

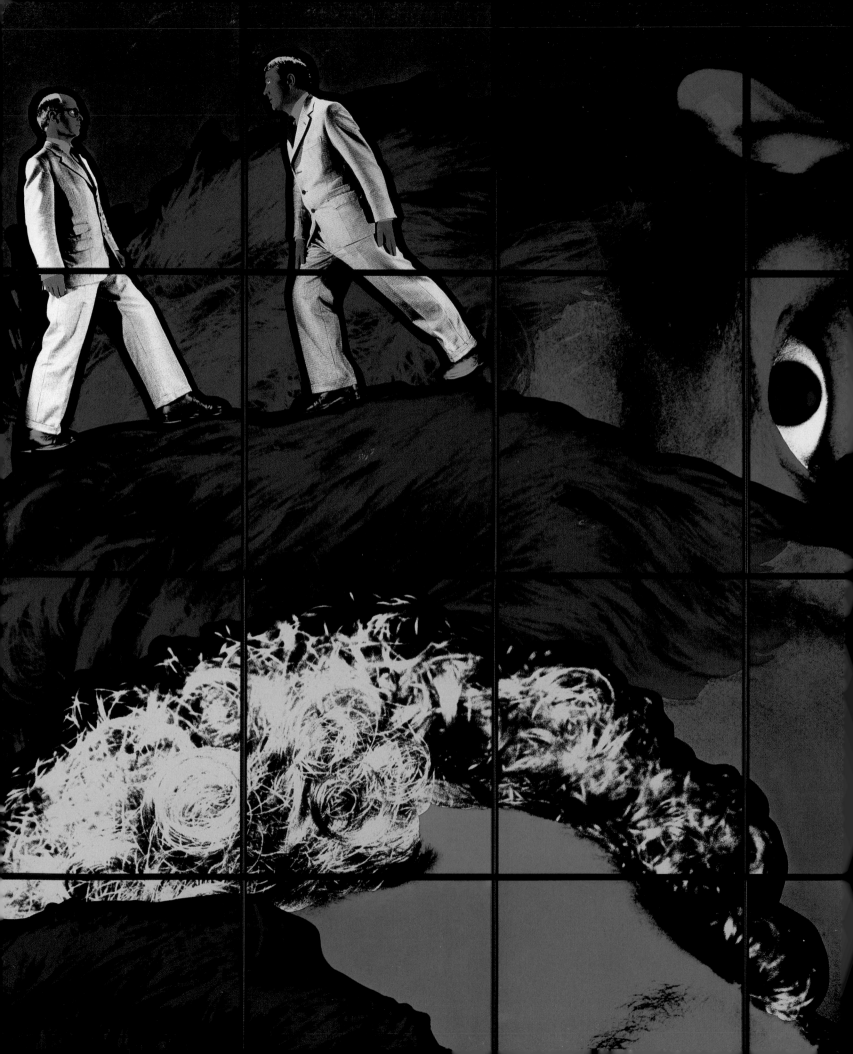

7 ARTIFICIALITY

ONE OF OSCAR WILDE'S preoccupations was the difference and similarity of Art to Artificiality. One can even hear the sententious, senatorial tone of his pronouncements as one reads them from the page:

'To be natural is such a very difficult pose to keep up.'

'No great artist ever sees things as they are. If he did he would cease to be an artist.'

'Being natural is simply a pose and the most irritating pose I know.'

To some, the very word 'Art' is shorthand for 'Artificiality' and not the process of creativity or the work itself. Art is artifice, art is artificial because, of course, it is not the real thing but a representation of the real thing — whether a sitter, subject or abstract idea transformed by brush, chisel, lens, or other means.

Gilbert & George argue that art is artificial because it is inventive. A small seed of an idea may produce a very Hydra, due to the complex capabilities of the mind. And if, rather like the vertable Hydra, you attempt to remove one of the heads, invariably more (and certainly more than the classical two) take its stead. Although the recent dictionaries might list under their 'Art' listing, a definition of 'Artifice' as archaic, the conjoining is clear and true. Consider and compare some of the precise meanings of Art and Artificiality:

detail of
Rest. 1984.

 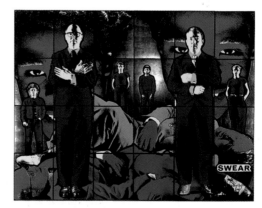

Rest. 1984. 241 x 201 cm. **Fruit God Fear.** 1982. 300 x 250 cm. **Swear.** 1985. 241 x 301 cm.

ART	ARTIFICIALITY
Facility	Man-made
Aptitude	Manufactured
Artistry	Non-natural
Craft	Plastic
Dexterity	Synthetic
Expertise	Bogus
Mastery	Counterfeit
Virtuosity	Imitation
Adroitness	Mock
Knack	Sham
Knowledge	Simulated
Profession	Affected
Skill	Hollow
Trade	Unnatural

INGENUITY INSINCERITY

If art grows from artifice (or indeed, artifice from art), if one feeds the other, one has the perfect conjoining of apparent opposites – an uncomfortable yin and yang of equal and opposite. If so, the inspiration, in itself, pure, true and enlightening can only be created through the most basic, practical and physical ways.

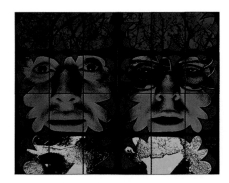

View. 1983. 241 x 301 cm.

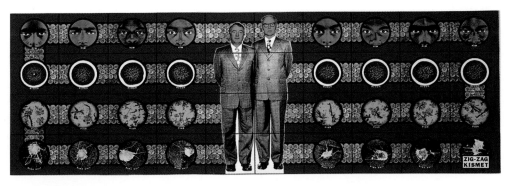

Zig-Zag Kismet. 2000. 284 x 845 cm.

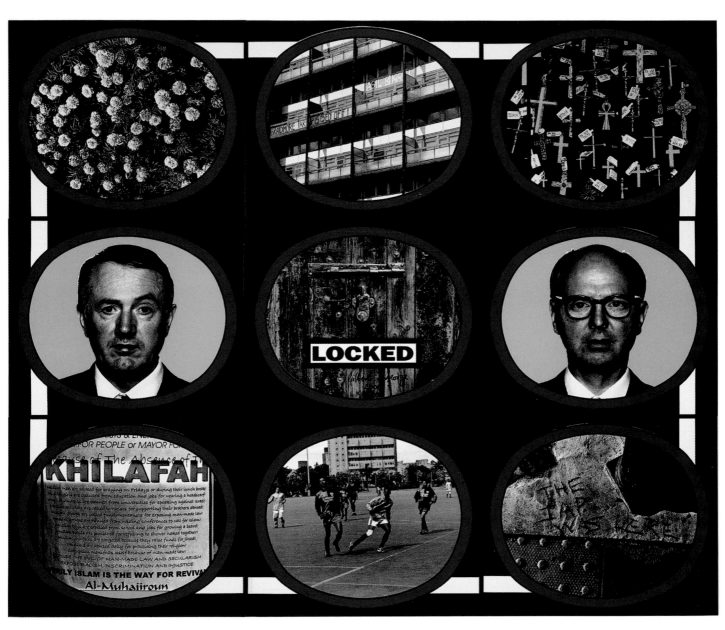

LOCKED. 2001. 190 x 226 cm.

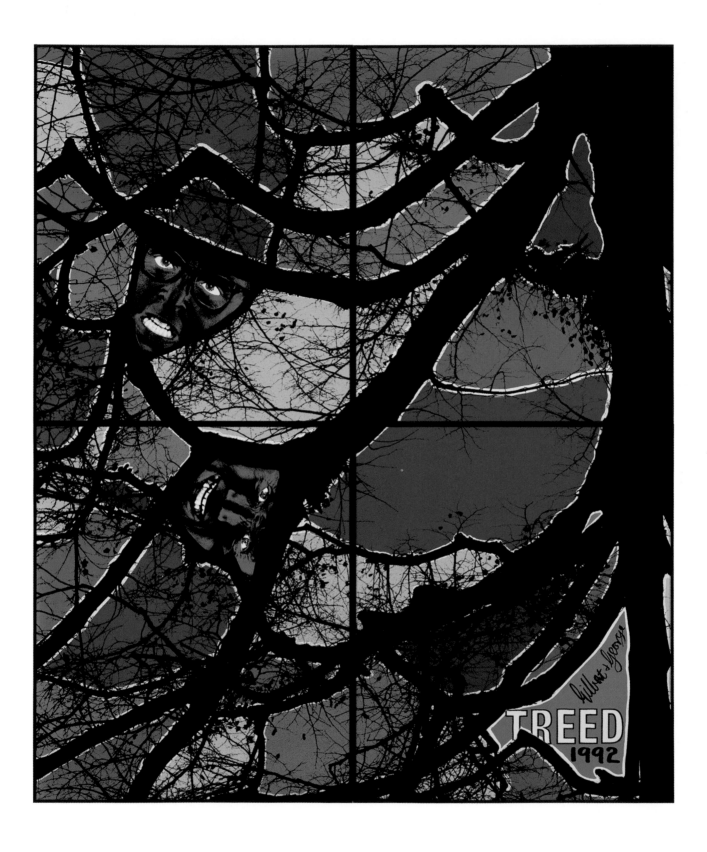

When Gilbert & George state, almost as an edict, that one must create artificial art, there is a neat dichotomy that is between the means of production and the idea itself.

By their own admission, they state that there are no definite rules and in any case, they have artificially arranged new ones which in turn can be torn down and reconstructed into a new edifice to suit a moment, a change of heart or what they will. Rules are, after all, by nature brittle, often ossify and eventually crumble to nothing. Others might add that even before a brittleness can set in, rules ought to be challenged and demolished.

Gilbert & George use a highly artificial means of presentation to display hugely real truths. The directness of the art – the bold, almost acidic primary colours, the stark figures and precise attitudes that cannot be confused certainly reinforce their sentiments. And although invariably on the large scale and featuring several images and elements, the impetus and message can be straightforward and even simple. And however simple, they will make it truthfully direct. They feel that,

> 'Everyday reality is invisible. When you have a frozen moment of life, as in our pictures, then it is supposed to mean something. You can pass ten thousand people crossing London Bridge in the morning, but if there is one who comes to you, takes you by the arm and says: "I want to say something to you," then you remember.'

Presumably, their art is the bold one with the persuasive, friendly hand.

One might now suggest that the way that Gilbert & George choose to be depicted in in their art has that same stiff, formal artificiality so much at odds with the very earliest ones. Study them closely. As students they wear suits but Gilbert's is thrown open with, God forbid, a chunky cable knit lurking beneath. George's is black, funereal and single-buttoned. A lack of money at the time obviously necessitates second-hand threads but one does get the feeling that the rigidity so familiar in later years has not become quite so hard boiled as yet.

TREED. 1992.
169 x 142 cm.

In later images, after acquiring their Spitalfields home and studio, Gilbert sports a hairy, tweedy, wide-lapelled number and George, a '60s high-notch Italian style example. Much later, and the styles coalesce and resemble the image with which most are familiar today – three-buttoned suits, subtly mismatched (with all three buttons done up) the last uncomfortably locking the skirt of the jacket together.

This is a purely artificial look. It is a complete, personal stamp of individuality and perhaps rebellion as it is immediately apparent and immediately puzzling. They harken back to images of bygone characters who did indeed wear all buttons done up. But those were differently cut garments. What Gilbert & George wear are basically rather conventional suits where the norm has always been to leave the third and last button undone stemming from early equestrian roots where the skirt of the jacket was intended to spread out over the horse's back.

Their stock answer as to why three working buttons is plain and unequivocal. Actually, it is also quite reasonable too. 'We like them,' they say disarmingly. And in any case, Gilbert & George often have their suits tailored to enable them to flout sartorial convention.

But second hand, Burton high street or bespoke, they plumped for suits from the start – a revelation and revolution in the early '70s when glam rock was just beginning and sequins, face paint, loons and platforms were becoming the rage. Bolan, Bowie and Ferry were the camp lamplighters along the new way. Gilbert & George looked, surely, out of place reactionary in their monochrome uniforms set against all these fay rainbows. They acknowledge as much themselves. Whilst perhaps being true to themselves, to the outside world it surely appeared the height of artificiality, not to say, affectedness.

ONE. 1988.
300 x 300 cm.

NINETEEN NINTY NINE. 1999. 352 x 2390 cm.

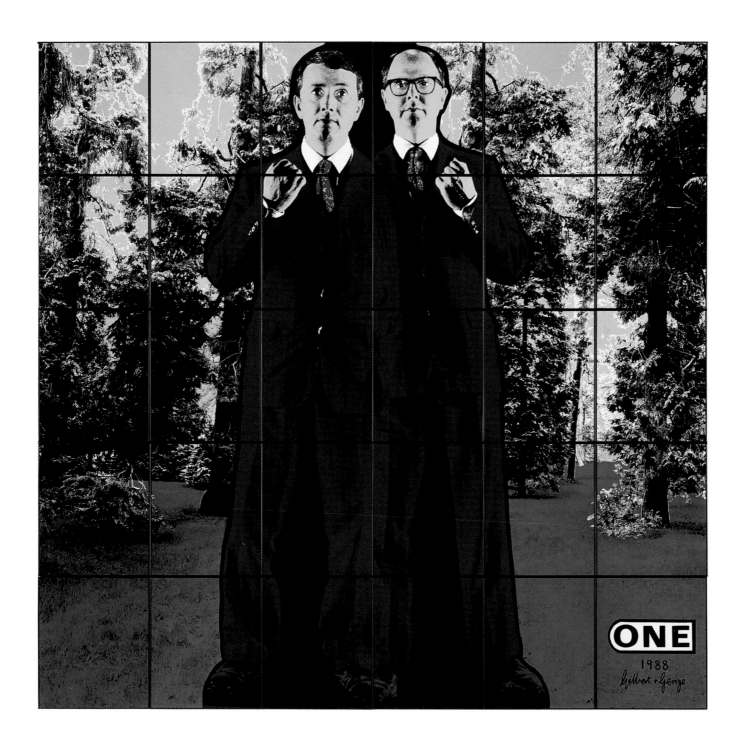

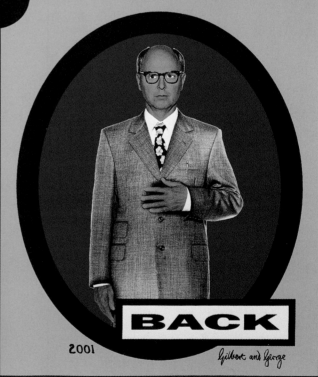

Gilbert & George surely would champion Artificial Art against the crushing reality of the constant barrage of, as they put it, 'Death and sport, death and sport, death and sport'. By making very careful, very consciously constructed artworks with very real motives and causes, they address central issues that are often closer to home than one might like to admit.

We are more and more at home with artificial things. A few can surely remember those plastic daffodils which were the golden prizes if you saved up enough soap powder coupons. And then, one might be reminded of Lady Sackville West (Vita's mother) who preferred to have a garden of velvet, silk and sequin blooms compared to the real thing. Artificial intelligence is now not so much an idea as a 'coming soon' reality and almost unbelievable shock stories of a genetically, artificially produced slave class, a frightening possibility to take the fiction of Huxley and make it tangible. We walk about in artificial fibres that cool down and heat up accordingly. We eat artificially made, preserved and enhanced food. We actually live more artificial lives than ever before – vicariously through the television, for example, watching the embarrassing arena antics of fame desperadoes. All this brings us back to the bare nature of Gilbert & George's art – to address all people, to address all relevant subjects and to try, in the process, to love all.

BACK. 2001.
169 x 142 cm.

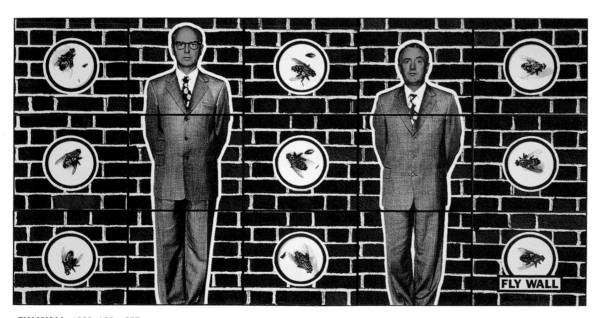

FLY WALL. 1998. 190 x 377 cm.

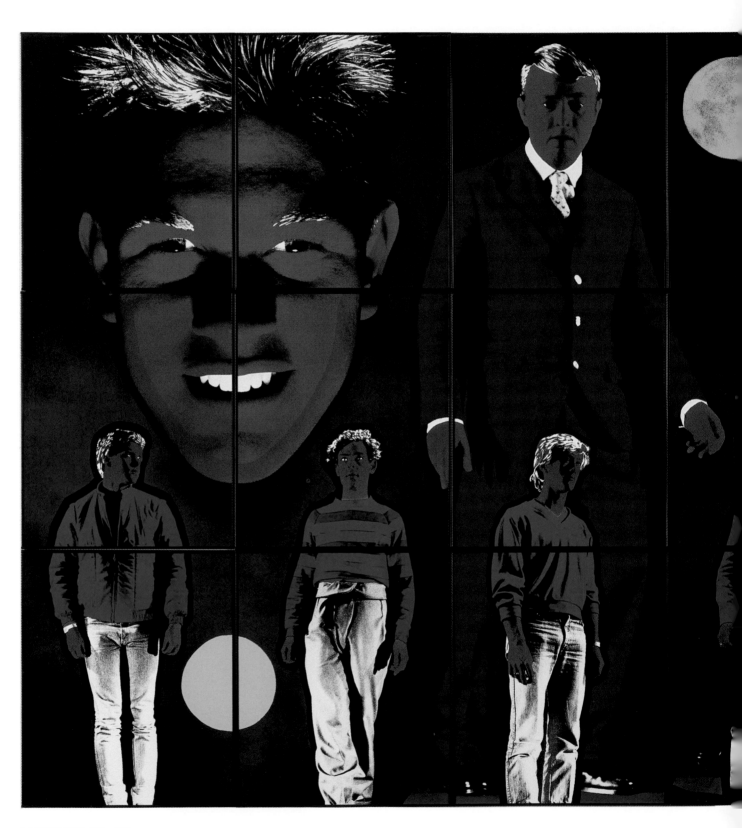

MOONS 1985. 181 x 351 cm.

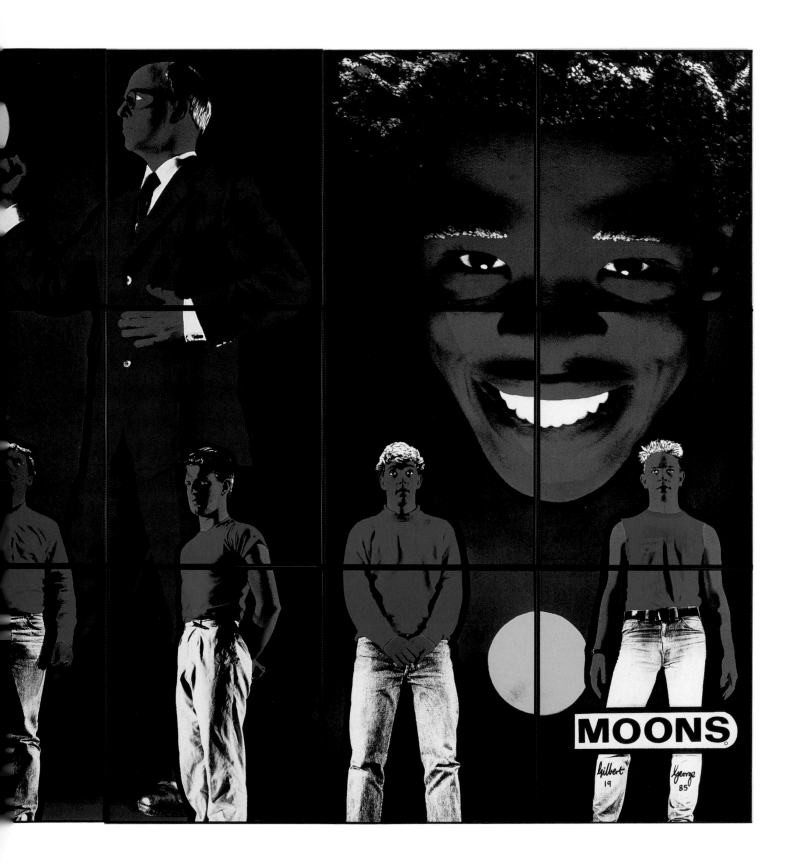

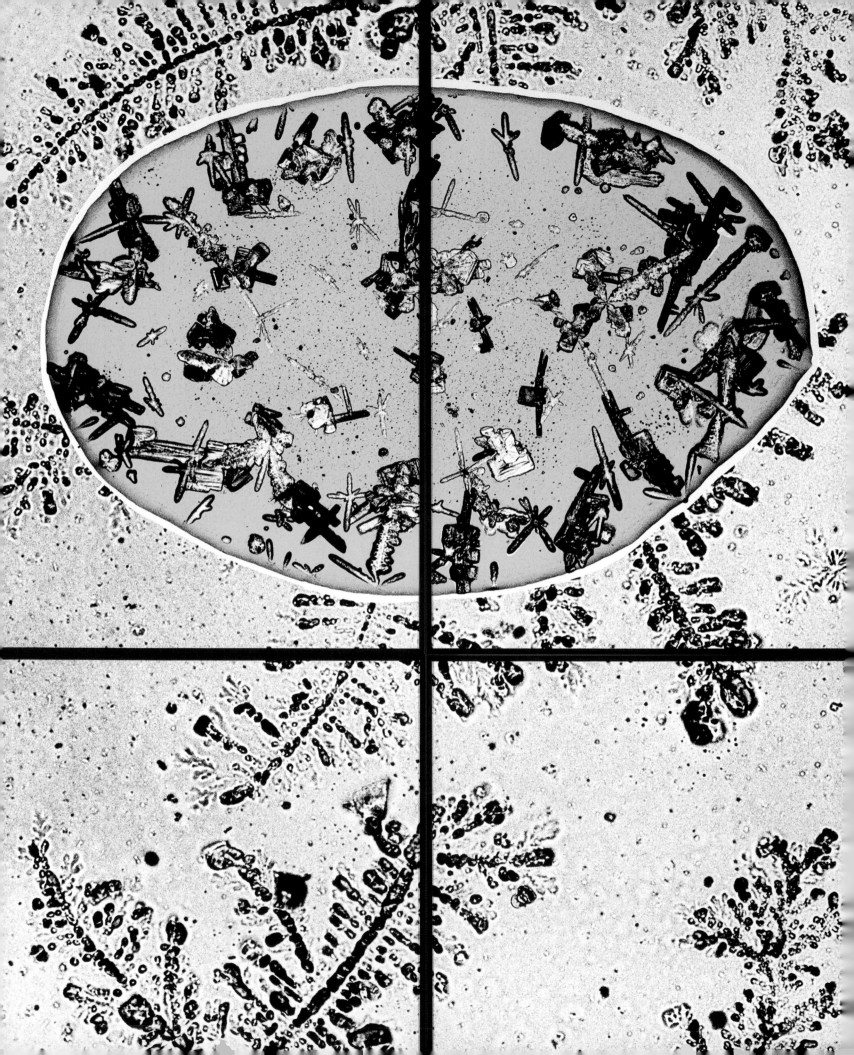

8 PURPOSE

WHEN GILBERT & GEORGE step into their studio they have to be, as they have often said, 'as empty as possible'. They have to be as clear as the blank space they will eventually fill with resounding colours and life-size figures. They are committed to concentration – to stumble, to fall over their latest inspiration. But most important of all, they must be a blank canvas, virgin territory, an area where everything and practically anything is possible.

> 'When we step into the studio we have to be crazed and empty-
> headed. We want to take away all our consciousness, leaving only
> how we love, how we hate, how we fear...'

Why, of course, might be taken for granted since we can surely all relate to these three very human – in fact, animal and basic emotions and natural concepts. But how we do something is another matter. It is more multifarious, individual, an expression of the personality of the self, itself. They have spoken at length about the purpose of making art and cite for example, the simple, uncluttered nature of a tribal person making a sculpture and the fact that the process and the end result is not called art as the intention is to make something for god, something devotional and a solid statement of a thought or article of faith.

detail of
Piss on Tears. 1997.

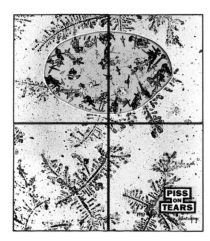

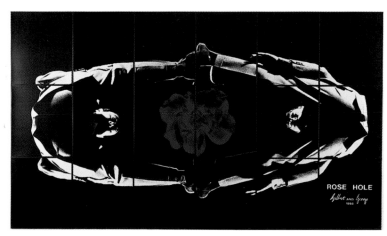

Piss on Tears. 1997. 251 x 127 cm. **Rose Hole.** 1980. 181 x 300 cm.

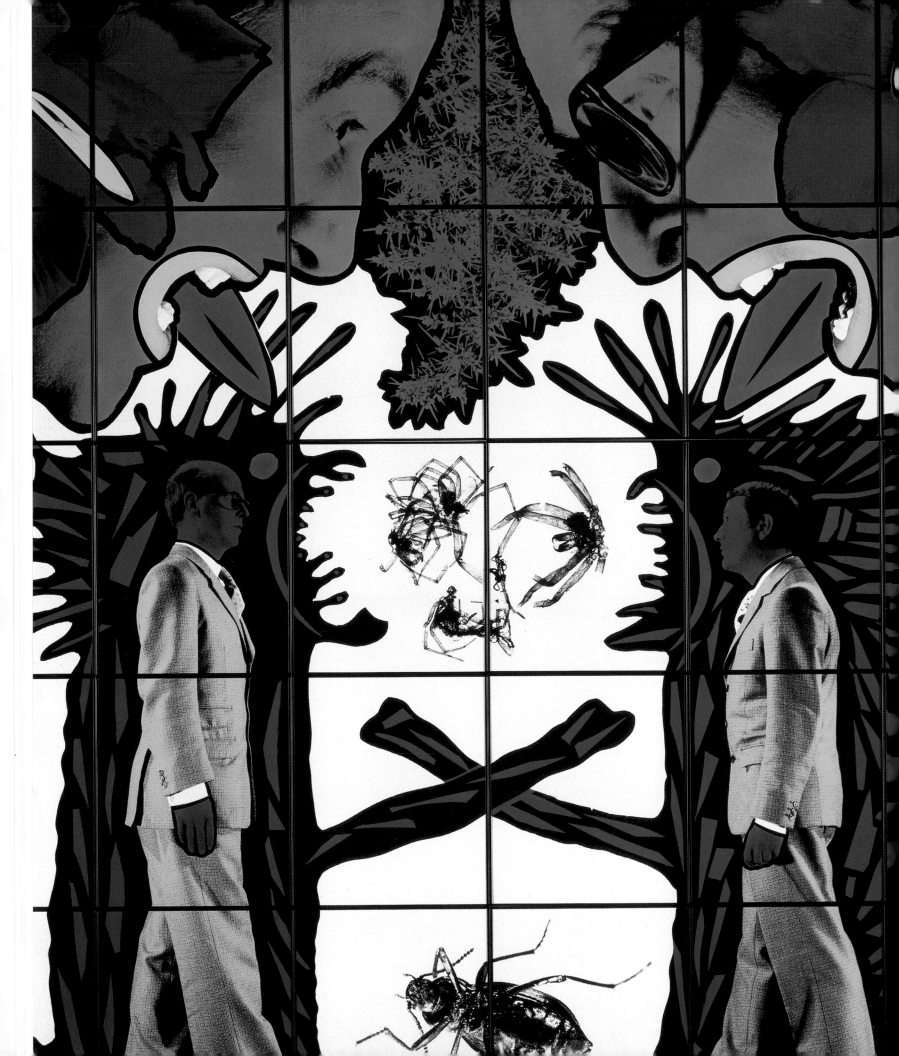

9 DOING

WHEN ONE *does* something, one generally supposes, logically, that there is a clear intent. It is a positive decision, a stance, an idea and generally, there is a hoped-for outcome. In the case of Gilbert & George, tactically contrary, perhaps, doing dons a slightly different mantle. Cheerfully they admit that they are unsure of themselves but are motivated to create anyway.

The end result of their efforts and of the pictures themselves (always so polished and self-assured) belies the original creative spirit. 'When making pictures,' they state, 'we have to be completely convinced that we are wrong.'

This feeling of being wrong, or at least, perhaps entertaining few moments of very real doubt, surely creates a more volatile, liquid, mutable world where ideas are not set – yet. It is almost as if the final work is the real master and the masters themselves, servants. If one compares the creation of art to alchemy, a connection can be considered if not embraced.

Alchemy is the age-old search for products and substances – most commonly gold – although bread has also been a goal. All those very real enthusiasts, charlatans and quacks with silver tongues made the search their lives' work. These characters were conscious of the *performance, experimentation* and *combining* of different elements in the long and problematic search. Ingredients had to be of a certain purity, added when the moon was favourable or on a certain day, at a certain hour.

The great charlatan, priest, sex maniac and general genius, Casanova was at some stage in his bizarre career a polished quack, dabbling in the cabbala and selling the 'secret' of doubling the quantity of mercury to a Greek merchant. (He doubled it of course, but it was not pure and so, unusable.) The end result of alchemy as well as art is 'gold' – in the latter's case, the gold of conveyed, understood, appreciated ideas. And both rely on time and experimentation. But in the case of art, the goal of gold is marginally more achievable.

detail of
Inside. 1983.

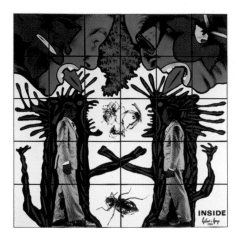

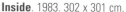

Inside. 1983. 302 x 301 cm.

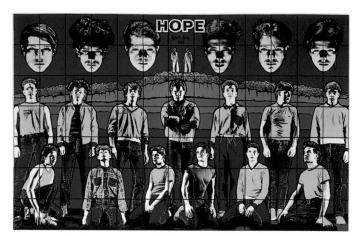

Hope. 422 x 652 cm. from Death, Hope, Life, Fear. 1984.

The fact that one cannot really create actual gold through any alchemic means (yet) did not stop would be mystical grandees from trying. Discovery, it emerges, is as vital to Gilbert & George as the final result. Perhaps this is because, bearing in mind their sentiments about being wrong, the frenzy of experimentation and the accompanied excitement makes this an interesting journey.

'There is no example in the history of mankind of someone writing a book or composing a piece of music because he already knew how to do it. If you believe you are wrong in the first place, at least you have the chance to discover something.'

Discovering, uncovering, unmasking perhaps those great and central truths of the pair, which we can all by and large relate to very directly, is a statement of honest intent. Although multi-layered in choice of image, word and meaning, Gilbert & George's pictures hint at simple, tangible realities.

And if not a belief in being wrong, then certainly they hold dear the idea that they never really pinpoint what they want to think. The development of an idea is akin to the development of the good wine they so enjoy – and which in a generic alcoholic sense was

DOERS. 1984.
241 x 250 cm.

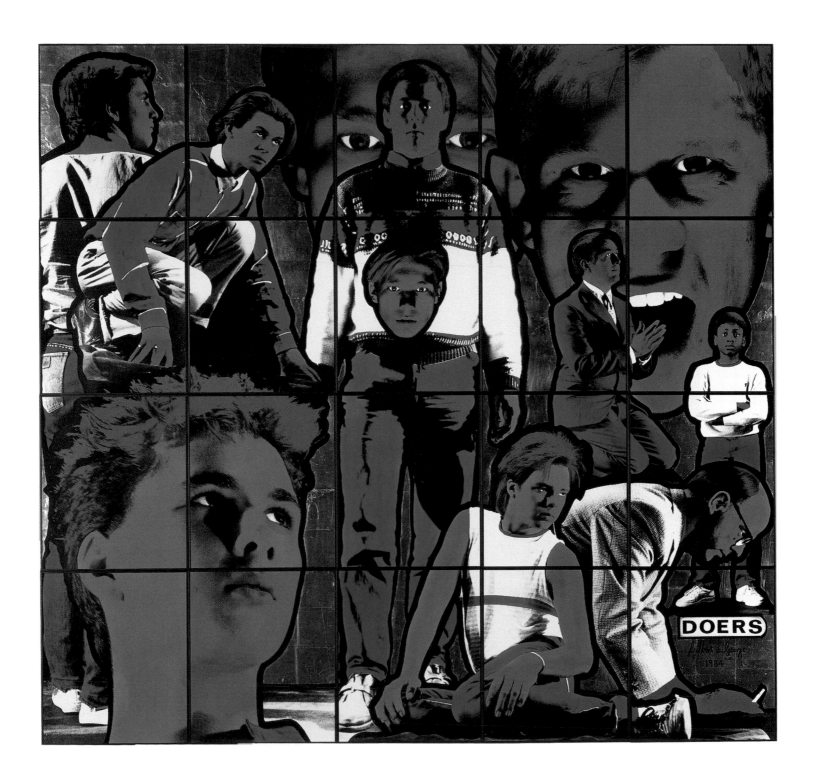

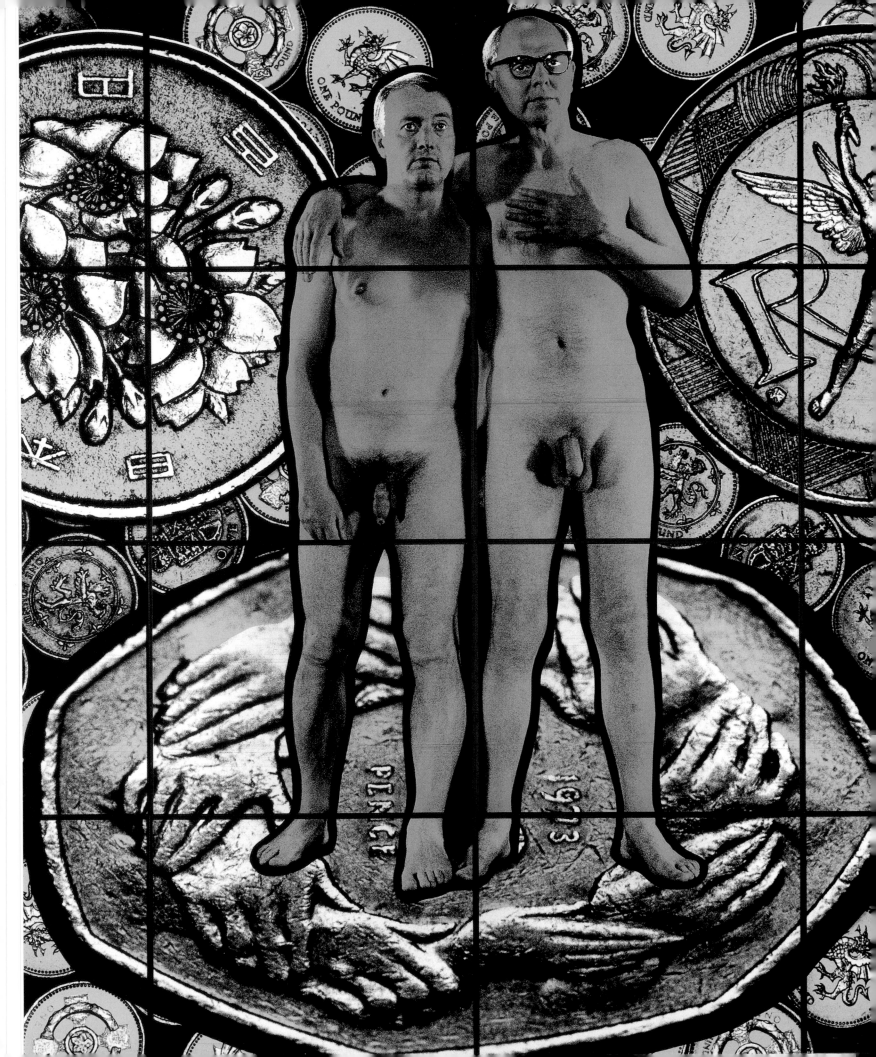

10 RECIPROCATION

WITH THIS LAST lodestone principle of Gilbert & George's, we really come full circle. What is the whole purpose of the journey? What is the reason for all the experimentation and discussion? Gilbert & George's point is that they have what they call 'the gift of life' and so are duty bound to simply give something back. This is a wholly moral, logical and dare one say it, identifiably Christian way of behaviour.

Gilbert & George do display seeming contradictions. They don't know what they do but they must do it. They make pictures which they want people never to forget, yet insist they do not make them for a defined public – or indeed, a general one. But the word 'contradiction' is not used here with mischief or malice in mind, nor employed in a pointedly critical way. Indeed, it is quite the opposite.

Their fluidity of ideas – which has been examined before – and the way their own views heat up and cool down, become distant or intimate, allowing a more expansive and less predictable agenda. What you see with Gilbert & George is definitely not instantly definable or easily boxed, quite unlike (in appearance, at least) their vast images, which are presented largely as one-dimensional cube-slices.

What rings clear and true with this particular preoccupation of Gilbert & George is a charmingly naïve sense of melancholy – not a wallowing in grief, nor yet a bitter anger. Instead, they express a touching doubt and an almost childlike enthusiasm, though fringed and tinged with sorrow. You can almost *hear* this in the tone of their words.

detail of
Blood Money. 1997.

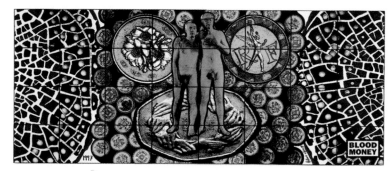

Blood Money. 1997. 254 x 604 cm.

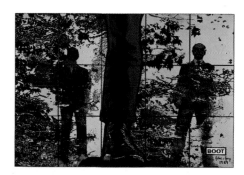

Boot. 1989. 226 x 317 cm.

'We identify with anyone who has given life abiding by the traditional idea that we are not here to please ourselves or to make ourselves happy.'

Are they idealists? Are they lay, secular preachers? Are they proto-dandies? Their life is a jigsaw constructed of pieces, which however you put them together, fit exactly.

Constantly referring to themselves as unhappy and depressed, they create their work with a curious, piquant mixture of arrogance and humility. It is a little like forcing two tastes together to counter the other and heighten both. Famously, black pepper is often sprinkled on strawberries. Unhappy, doomed, love-lorn John Keats often peppered his tongue before taking a slug of claret. So what they do becomes, quite simply, what they give.

In 1993, Gilbert & George went to China on the occasion of their exhibitions at the National Art Gallery, Peking and the Art Museum, Shanghai. Their visit in itself was surely momentous. How many other artists have managed to do that? Perhaps because of their relatively recent communist past (like Russia's) the Chinese could relate to the perceived idealism, bright primary reds and yellows, sheer, monumental size and clear message. At a press conference, the pair delivered *The China Statement* – a 'sculptural' introduction to their work, perhaps?

They clearly state in these words why they do what they do. Curiously, the tone seems to elicit a feeling of an almost spiritual rhetoric – or a little more fancifully, delivered in the spirit of Elizabeth I at Tilbury, (almost) emotionally thanking her people for letting her reign with their love.

'We are Gilbert & George. We as unhappy artists are very happy to be able to hold this exhibition of our pictures in China. Our art fights for love and tolerance and the universal elaboration of the individual. Each of our pictures is a visual love letter from

RUDE. 1981.
241 x 201 cm.

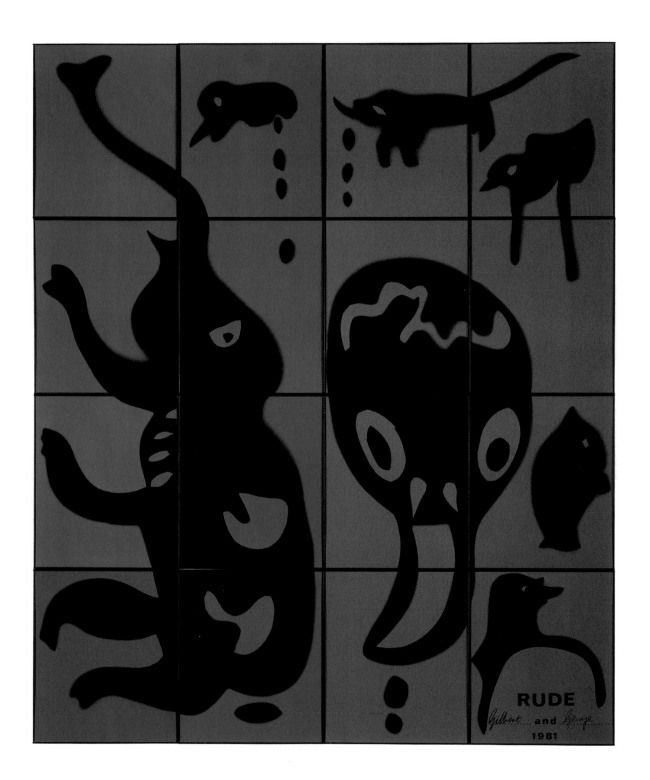

THE RED SCULPTURE, 1975, recreated here in 1997 for the Southbank Show.

Questions & Answers

Who are G&G?

G&G: We would say that we are the *weirdest* people we know. For many years we said that we were the unhappiest people we knew – and then we *actually* became unhappy, so we stopped saying it. More recently we stated 'we are the most *disturbed* people we know.'

Why G *and* **G?**

G&G: In two there is strength. We came together by chance as students and we never look back.

Why does G&G work?

G&G: Because we never asked ourselves this question. Our art is not based on what either one of us thinks or feels but upon what *we* think, feel, hope, dread, etc. We have a shared vision and an overdeveloped sense of purpose.

Why has G&G worked for so long?

G&G: There is always another day to do battle. One day there will be a last G&G picture and then it can all be seen complete.

detail of:
Winter Flowers. 1982.

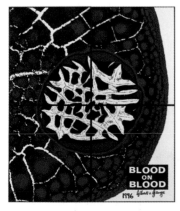

Blood on Blood. 1996. 151 x 127 cm.

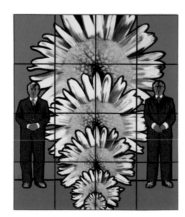

Stand. 1984. 241 x 201 cm.

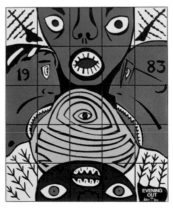

Evening Out. 1983. 300 x 250 cm.

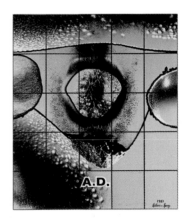

A.D. 1987. 300 x 250 cm.

Do G&G ever feel like a holiday from G&G?

G&G: The only holiday we take is in December to avoid the London Christian celebrations. We are very conscious of being *alone* and *together*.

Is it possible for G to work without G?

G&G: We never considered this. All the other artists are doing that.

Which artists from the past do G&G like?

G&G: We admire all the artists who gave of themselves to the point of personal damage, e.g. Samuel Palmer, Rembrandt, Francis Bacon, Vincent Van Gogh, William Blake, Andy Warhol, William Turner, William Holman-Hunt etc.

Which creative persons in other media do G&G admire?

G&G: Charles Dickens, Charles Darwin, Sir Joseph Paxton, A.W. Pugin, Edwin Luytens, Alfred Hitchcock, Powell and Pressburger, Alan Turing.

What advice have G&G to offer art students?

G&G: On waking in the morning – sit on the edge of the bed with closed eyes and decide 'what do I want to say to the world today?' *and* shag the teachers!

What advice have G&G to offer for living?

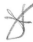 **G&G:** Never to hurt your neighbour (unless of course they like it!).

Rain on Us. 1998. 253 x 639 cm.

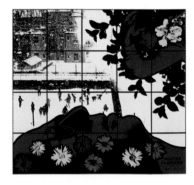

Winter Flowers. 1982. 241 x 25J cm.

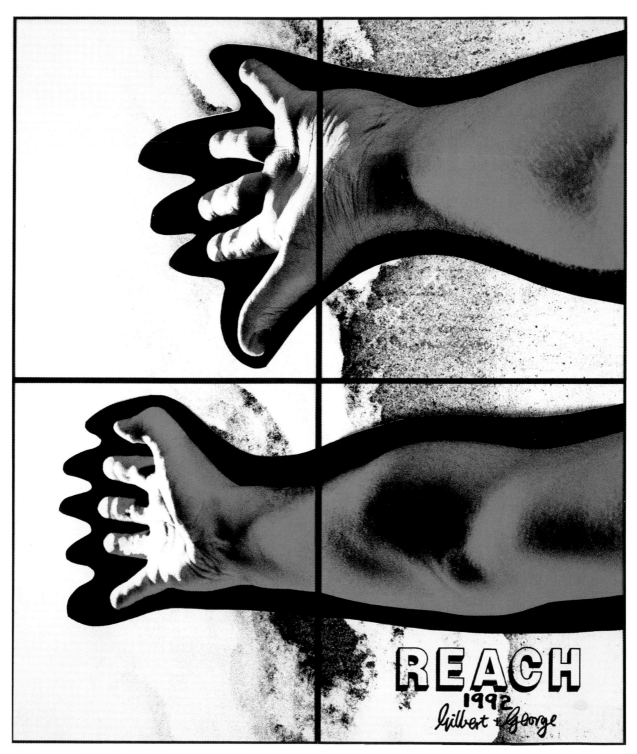

REACH. 1992. 169 x 142 cm.

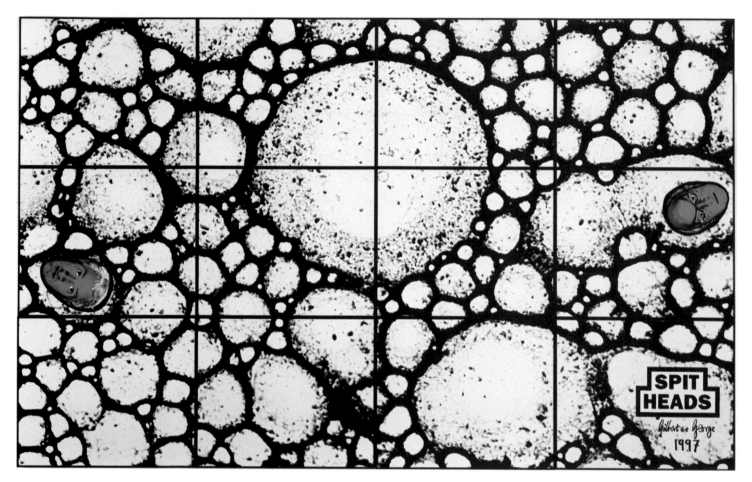

SPIT HEADS. 1997. 190 x 236 cm.

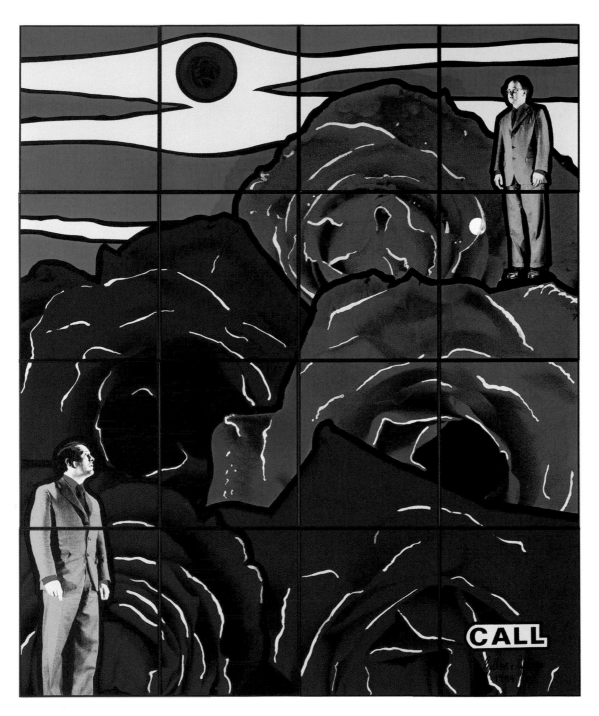

CALL. 1984. 241 x 201 cm.

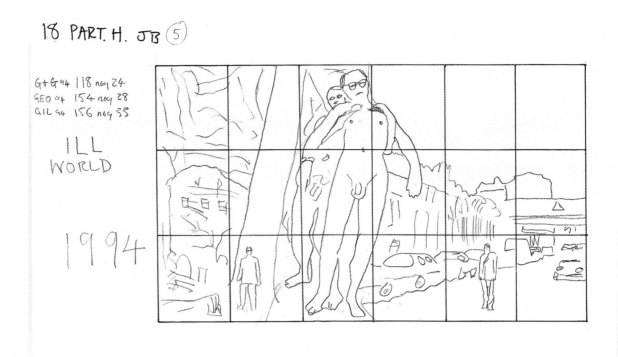

Working drawing for **Ill World**. Pencil and photocopy on paper.
1994. 59.4 x 42 cm.

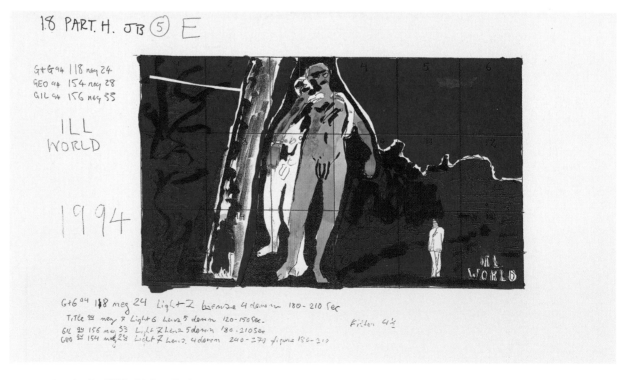

Working drawing for **Ill World**. Pencil, photocopy and ink on paper.
1994. 59.4 x 42 cm.

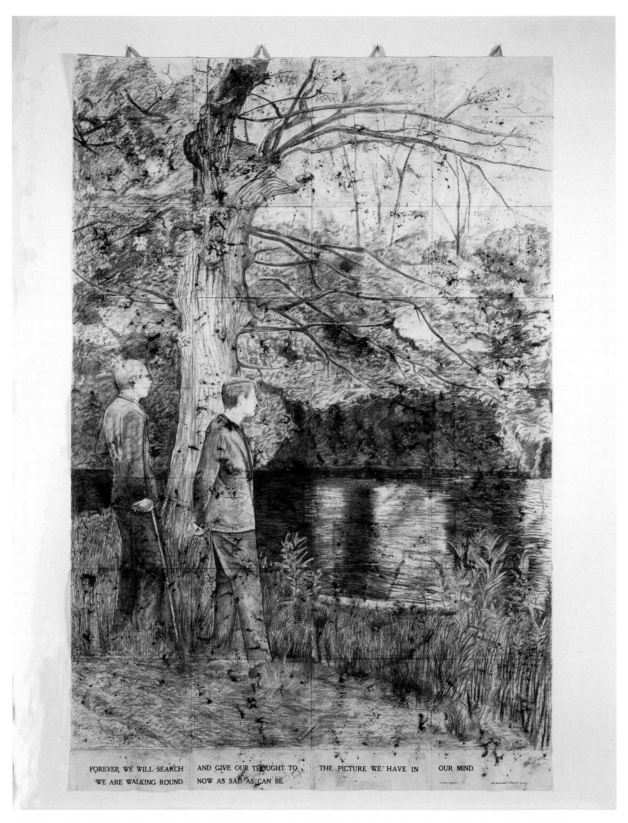

FOREVER WE SEARCH AND GIVE OUR THOUGHT TO THE PICTURE WE HAVE IN OUR MIND. WE ARE WALKING AROUND AS SAD AS SAD CAN BE. 1970. 348 x 236 cm. From The Nature of Our looking. A five-part charcoal on Paper Sculpture.

Installations

Gilbert & George plan and design all their exhibitions.
right: Their model of **The Dirty Words** exhibition, 2002.
below: **Shrubberies No1 and No2,** in the group show called the New Art, Hayward Gallery, 1972
far right, above and below: Musée d'Arte Moderne, **Retrospective** 1997.

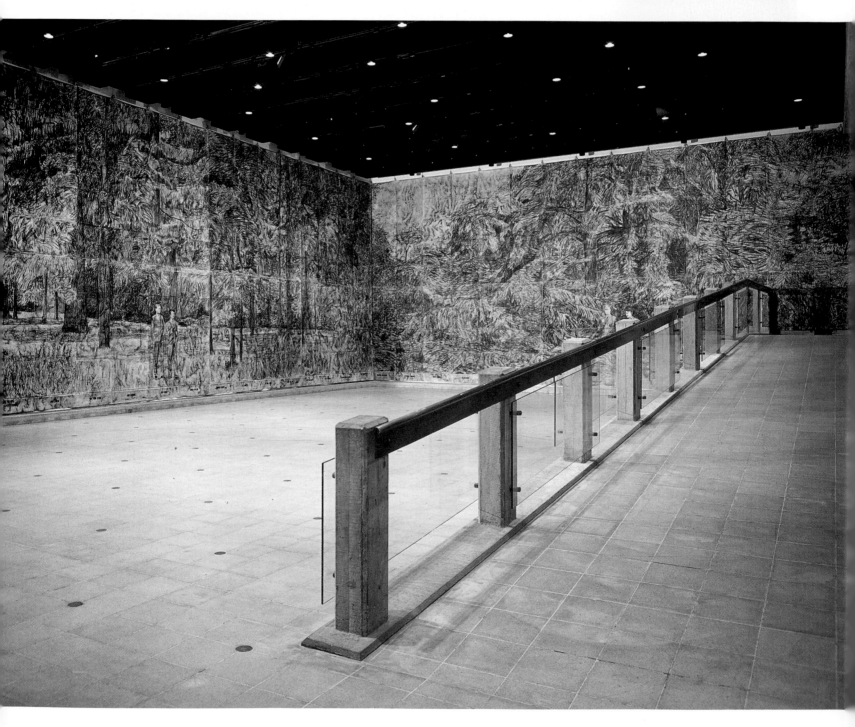

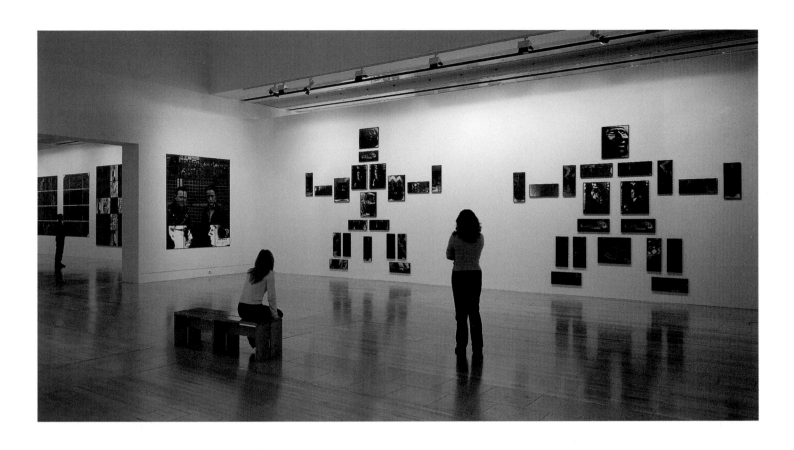

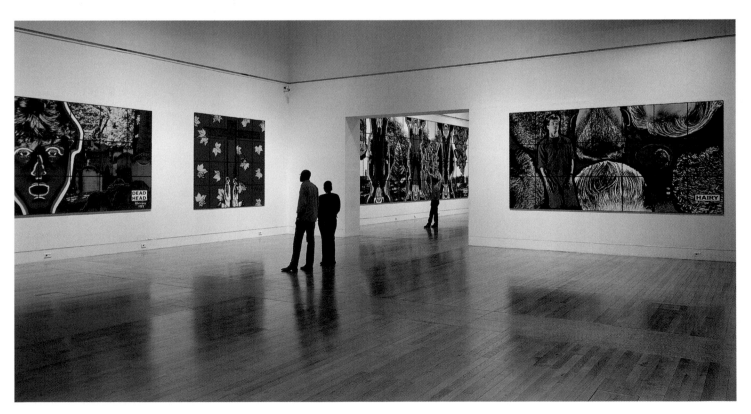

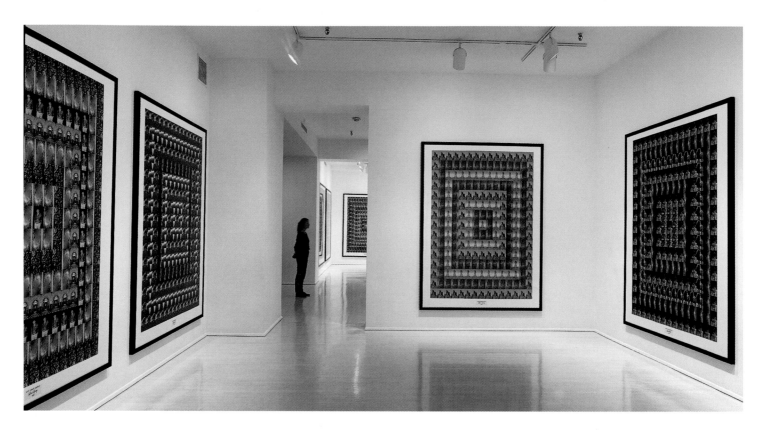

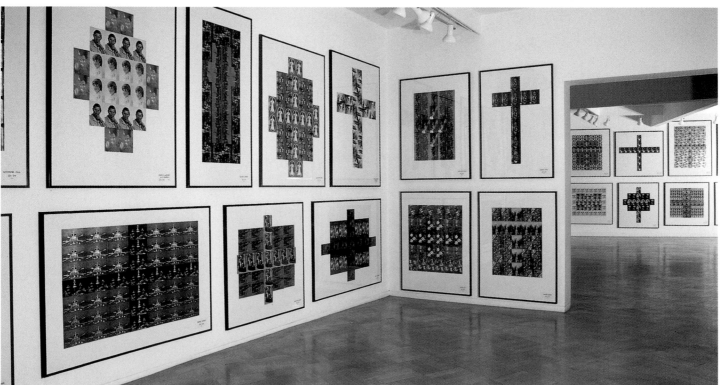

Installations: above; **Crusade.** An exhibition of Postcard Pieces in London. 1982.
top; **25 Worlds.** Postcard Pieces in New York. 1990.

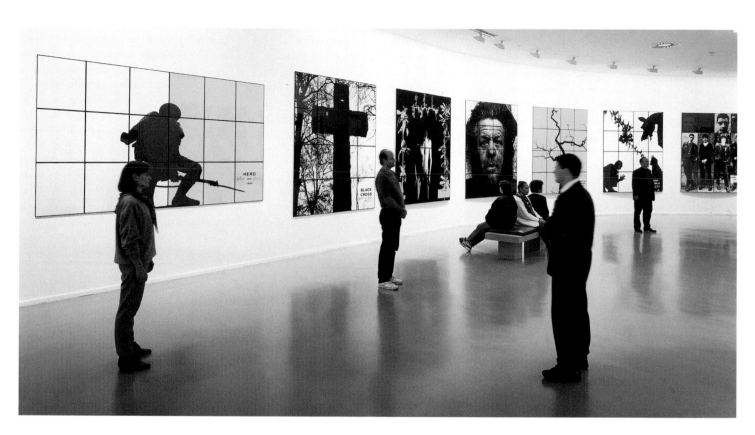

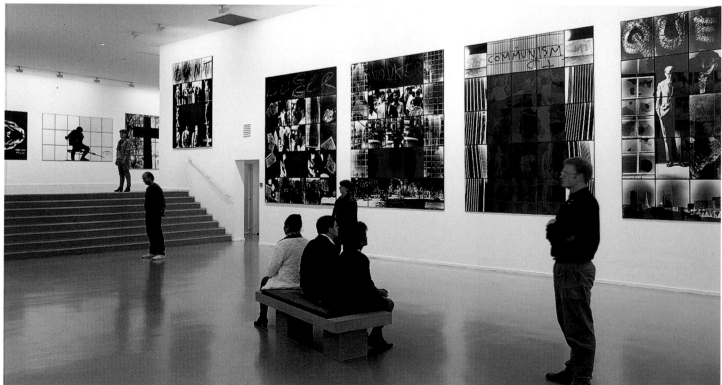

Installations: Musée d'Arte Moderne, **Retrospective** 1997.

 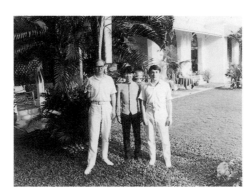

Fond Memories

Top: l to r: George's mother, Hermione Ernestine. Gilbert, second left, with brother, and sisters in the village where he grew up. Gilbert & George relax on the roof of St Martin's School of Art, London, 1968.

Second row: Gilbert's mother, Cecilia. George, second to left, with friends on their way to the annual carnival in Totnes, Devon. Story Sculpture at The Lyceum, London, 1969.

Third row: Gilbert centre, carving Madonnas in his father's workshop. Gilbert & George and barman Somsak in Bangkok, 1973. With dealer Nigel Greenwood in Australia, 1973.

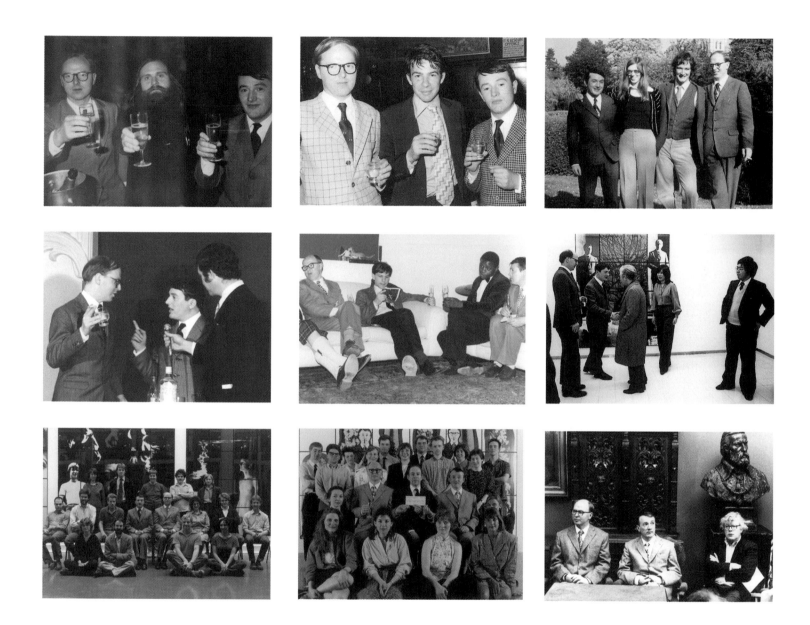

Top, l to r: G&G with artist Carl Andre, early 1970s. With Anthony d'Offay, c 1972. Best Men at David Tremlett's wedding.
Second Row: G&G interviewed in Australia. George with writer and critic Wolf Jahn, Paul Forrest and Gilbert. G&G in Japan.
Third row: With Nicholas Serota, top row second from left and the staff of the Whitechapel Art Gallery, 1981. With Anthony d'Offay and staff holding a cheque for £565,500 made out to Crusade, an Aids charity in May 1989 from the sale of G&G's For Aids Pictures. With Rudi Fuchs, director of the Stedelijk Museum, Amsterdam, at a press conference in Krahow.

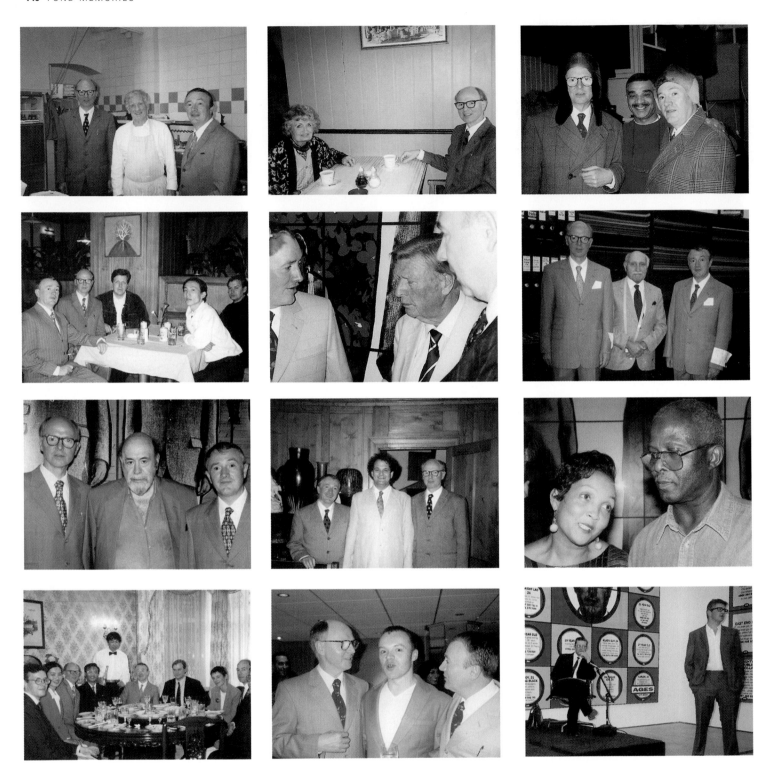

Top, l to r: G&G with Clyde, George with Phylis in the Market Cafe, where they breakfasted and lunched over 30 years, until its closure. With Danny their furrier.
Second row: Shanghai, in 1993 with James Birch, Raymond O'Daly and Yu Yi-Yang, now friend and helper. Gilbert with Daniel Farson, writer and biographer and then dealer Anthony D'Offay, Paris 1997, With David London, tailor to G&G.
Third row: With art critic David Sylvester. Inside their home with film maker Gerry Fox, maker of the multi-award winning documentary on G&G. June and Stainton Forrest, who looks after G&G.
Fourth row: At the Chinese embassy, in London. celebrating their retrospective in China. With Graham Norton, whilst appearing on his show, in 1999. Michael Bracewell and their dealer Jay Jopling, introducing an evening during *The New Horny Pictures* exhibition at the White Cube gallery in London.

Top, l to r: G&G celebrating at home with curator Hans-Ulrich Obrist. With gallery owners, Marina Eliades and Jean Bernier in Athens, 2002. With David Hockney, who has known G&G since the late '60s and Ealan Wingate, director of the Gagosian, Los Angeles, on the occasion of their showing the *Rudimentary Pictures*, 2000.
Second row: With Massimo Valsechi and Massimo Martino, close friends and collectors. With sexologist Shere Hite in their home. Writer, Robin Dutt.
Third row: With Antonio Hommem and Illeana Sonnabend, their New York dealer since 1971 at the Stedelijk Museum in Amsterdam. With Thaddaeus Ropac in Paris before a celebratory dinner at the showing of their *New Testamental Pictures*. With Nurul, friend and model, at the Mangal restaurant in North London.
Fourth row: With Jane and art critic Robert Rosenblum, and (standing) Head Waiter Pietro in London. Lovely Sandra, proprietor of the Golden Heart, brandishing a bottle of wine produced by the Restaurant Milanese in Milan, celebrating their China exhibitions. With Beatrice Parent, curator and director Suzanne Pagé in a London restaurant, planning a Paris show.

Biography

Gilbert
1943
Born, Dolomites, Italy
Studied Wolkenstein School of Art
Hallein School of Art
Munich Academy of Art.

George
1942
Born, Devon, England
Studied Dartington Adult Education Centre
Dartington Hall College of Art
Oxford School of Art.

1967 Met and studied at St Martin's School of Art, London.

Gallery Exhibitions

1968 Three Works/Three Works, Frank's Sandwich Bar, London.
Snow Show, St. Martin's School of Art, London.
Bacon 32, Allied Services, London.
Christmas Show, Robert Fraser Gallery, London.

1969 Anniversary, Frank's Sandwich Bar, London.
Shit and Cunt, Robert Fraser Gallery, London.

1970 George by Gilbert & Gilbert by George, Fournier Street, London.
The Pencil on Paper Descriptive Works, Konrad Fischer Gallery, Düsseldorf.
Art Notes and Thoughts, Art & Project, Amsterdam.
Frozen Into the Nature for you Art, Françoise Lambert Gallery, Milan
The Pencil on Paper Descriptive Works, Skulima Gallery, Berlin.
Frozen Into The Nature For You Art, Henier Friedrich Gallery, Cologne.
To Be With Art Is All We Ask, Nigel Greenwood Gallery, London.

1971 There Were Two Young Men, Sperone Gallery, Turin.
The General Jungle, Sonnabend Gallery, New York.
The Ten Speeches, Nigel Greenwood Gallery, London.
New Photo-Pieces, Art & Project, Amsterdam.

1972 New Photo Pieces, Konrad Fischer Gallery, Düsseldorf.
Three Video Sculptures on Video Tape, Gerry Schum Video Gallery, Düsseldorf.
The Bar, Anthony d'Offay Gallery, London.
The Evening Before the Morning After, Nigel Greenwood Gallery, London.
It Takes a Boy to Understand a Boy's Point of View, Situation Gallery, London.
New Sculpture, Sperone Gallery, Rome.

1973 Any Port in a Storm, Sonnabend Gallery, Paris.
Reclining Drunk, Nigel Greenwood Gallery, London.
Modern Rubbish, Sonnabend Gallery, New York.
New Decorative Works, Sperone Gallery, Turin.

1974 Drinking Sculptures, Art & Project/MTL Gallery, Antwerp.
Human Bondage, Konrad Fischer Gallery, Düsseldorf.
Dark Shadow, Art & Project, Amsterdam.
Dark Shadow, Nigel Greenwood Gallery, London.
Cherry Blossom, Sperone Gallery, Rome.

1975 Bloody Life, Sonnabend Gallery, Paris.
Bloody Life, Sonnabend Gallery, Geneva.

Bloody Life, Lucio Amelio Gallery, Naples.
Post-Card Sculptures, Sperone Westwater Fischer, New York.
Bad Thoughts, Gallery Spillemaekers, Brussels.
Dusty Corners, Art Agency, Tokyo.

1976 Dead Boards, Sonnabend Gallery, New York.
Mental, Robert Self Gallery, London.
Mental, Robert Self Gallery, Newcastle.
Red Morning, Sperone Fischer Gallery, Basel.

1977 Dirty Words Pictures, Art & Project, Amsterdam.
Dirty Words Pictures, Konrad Fischer Gallery, Dusseldorf.

1978 Photo-Pieces, Dartington Hall Gallery, Dartington Hall.
New Photo-Pieces, Sonnabend Gallery, New York.
New Photo-Pieces, Art Agency, Tokyo.

1980 Post-Card Sculptures, Art & Project, Amsterdam.
Post-Card Sculptures, Konrad Fischer Gallery, Dusseldorf.
New Photo-Pieces, Karen & Jean Bernier Gallery, Dusseldorf.
New Photo-Pieces, Sonnabend Gallery, New York.
Modern Fears, Anthony d'Offay Gallery, London.
Photo-Pieces 1980 to 1981, Chantal, Crousel Gallery, Paris.

1982 Crusade, Anthony d'Offay Gallery, London.

1985 New Moral Works, Sonnabend Gallery, New York.

1986 New Pictures, Anthony d'Offay Gallery, London

1987 New Pictures, Anthony d'Offay Gallery, London.

1988 The 1988 Pictures, Ascan Crone Gallery, Hamburg.
The 1988 Pictures, Sonnabend Gallery, New York.

1989 The 1988 Pictures, Christian Stein Gallery, Milan.
For Aids Exhibition, Anthony d'Offay, London.

1991 20th Anniversary Exhibition, Sonnabend Gallery, New York.

1992 New Democratic Pictures, Anthony d'Offay Gallery, London.

1994 Gilbert & George, Robert Miller Gallery, New York.
The Naked Shit Pictures, Galerie Rafael Jablonka, Cologne.

1995 Gilbert & George, Galerie Nikolas Sonne, Berlin.

1997 The Fundamental Pictures, Sonnabend Gallery/ Lehmann Maupin, New York.

1998 Selected Works from The Fundamental Pictures, Massimo Martino Fine Arts & Projects, Switzerland.
New Testamental Pictures, Galerie Thaddaeus Ropac, Paris.
New Testamental Pictures, Galerie Thaddaeus Ropac, Paris.
New Testamental Pictures, Galerie Thaddaeus Ropac, Salzburg.
Black White and Red, James Cohan Gallery, New York.

2000 Gilbert & George, Parkhaus, Düsseldorf.
Zig-Zag. Pictures 2000, Galerie Thaddaeus Ropac/FIAC, Paris.
The Rudimentary Pictures, Gagosian Gallery, Los Angeles.